General Editor
David Piper

MICHELANGELO

Every Painting

Introduction by Cecil Gould
Keeper of the National Gallery, London, 1973–8

Catalogue by Enio Sindona
translated by Jane Carroll

RIZZOLI NEW YORK

Foreword by the General Editor

Several factors have made possible the phenomenal surge of interest in art in the twentieth century: notably the growth of museums, the increase of leisure, the speed and relative ease of modern travel, and not least the extraordinary expansion and refinement of techniques of reproduction of works of art, from the ubiquitous colour postcards, cheap popular books of colour plates, to film and television. A basic need – for the general art public, as for specialized students, academic libraries, the art trade – is for accessible, reliable, comprehensive accounts of the works of the individual great masters of painting; this has not been met since the demise before 1939 of the famous German series, *Klassiker der Kunst*; when such accounts do appear, in the shape of full *catalogues raisonnés*, they are vast in price as in size, and beyond the reach of most individual pockets and the capacity of most private bookshelves.

The aim of the present series is to provide an up-to-date equivalent of the *Klassiker* for the now enormously enlarged public interested in art. Each volume (or volumes, where the quantity of work to be reproduced cannot be contained in a single one) catalogues and illustrates chronologically the complete paintings of the artist concerned. The catalogues reflect as far as possible a consensus of current expert opinion about the status of each picture; in the nature of things, consensus has yet to be reached on many points, and no one professionally involved in the study of art-history would ever be so rash as to claim definitiveness. Within the bounds of human fallibility, however, every effort has been made to achieve both comprehensiveness and factual accuracy, while the quality of reproduction aimed at is the highest possible in this price range, and includes, of course, colour. Every effort has also been made to hold the price down to the lowest possible level, so that these volumes may stay within the reach not only of libraries, but of the individual student and lover of great painting, so that they may gradually accumulate their own 'Museum without Walls'. The introductions, written by acknowledged authorities, summarize the life and works of the artists, while the illustrations place in perspective the complete story of the development of each painter's genius through his career.

David Piper

Michelangelo
as Painter

by Cecil Gould

It is a strange phenomenon that success and ambition sometimes pull in different directions. Hogarth, the satirist, and Reynolds, the fashionable portraitist, both wanted to paint solemn histories; Sullivan longed to get rid of Gilbert and write grand opera; Newton considered it his mission to explain the Bible rather than the physical secrets of the universe, and Turner spent much of his time trying to write poetry. Famous comedians are usually supposed to want to play Hamlet.

With Michelangelo's incursions into painting the pressure went the other way – at least, according to him. It was not a question of misguided ambition leading to failure, but of reluctance overcome and resulting in overwhelming success. He was the creator of the ceiling of the Sistine Chapel, which many people see as the pinnacle of western painting. Yet he consistently denied that painting was his trade. The fact that both in his lifetime and during most of the intervening centuries he was regarded as the greatest sculptor who had ever lived is no more than a partial explanation of his reluctance to paint, since Florentines of the preceding generation, such as Antonio Pollaiuolo or Verrocchio, seem to have worked happily in both arts.

One explanation probably lies in the controversy concerning the respective merits of painting and sculpture. This became a burning issue in Michelangelo's lifetime, and he saw himself as the leader of the sculptors' party. At the same time it is possible that he also had a personal reason for the stance which he took up. There was a strong vein of asceticism in his character. He seems to have been almost impervious to physical discomfort, and he had a corresponding contempt for any symptoms of softness in other people. And this may well have affected his preference for marble carving, as being vastly more strenuous than either modelling or painting.

Regarding Michelangelo's views on the controversy we are fortunately well informed. In the 1540s the humanist, Benedetto Varchi, had sent out invitations to various painters and sculptors to express their opinions. In his reply Michelangelo said in effect that he saw no fundamental difference between painting and sculpture. Painting, in his view, was good to the extent that it resembled sculpture (he actually used the word 'relief') and sculpture bad to the extent that it resembled painting. This undoubtedly provides us with an authentic and fascinating key to Michelangelo's own aims in his painting, and everyone who looks at it should bear his words constantly in mind. But we must also bear in mind that on Michelangelo's criterion most of the work of Titian would rank as bad painting.

The mention of Titian, and the distinction drawn by Michelangelo between painting which resembled sculpture and painting which did not, leads us to another controversy. Not only were the painters in Michelangelo's day forced into rivalry with the sculptors; correspondingly fierce differences were discovered between draughtsmanly and painterly painters – that is, in effect, between painters whose ideal was the art of Antiquity, and those, such as the Venetians, who based their art more directly on Nature.

This time Michelangelo had a personal interest, and a degree of personal involvement, of a not entirely creditable kind. Despite his triumph with the Sistine ceiling there were those in Rome in the years 1512–16, or thereabouts, who championed the merits of the young Raphael in opposition to him. It was agreed that Michelangelo's incomparable draughtsmanship rendered him supreme as painter of the nude (actually, only male). However, it was also claimed that whereas Raphael was supreme in almost every branch of painting Michelangelo could paint nothing *except* nudes. Naturally, Michelan-

gelo resented this, and he was astute enough to realize that Raphael, at that time, still had an Achilles heel. The painterly qualities, including the factor of colour itself, were not really Raphael's forte, any more than they were Michelangelo's. In point of fact Raphael seems to have realized this himself at about the same time, and the remedy he adopted was the same as what Michelangelo envisaged, namely Venetian painting. But whereas Raphael set himself to remodel his technique through study of Venetian methods, Michelangelo had no intention either of changing his ways or of intervening in the dispute in person. His plot (it was hardly less) was to coach the young Venetian, Sebastiano Luciani, afterwards called del Piombo, in drawing, and hope that this, allied to his native Venetian skill as colourist, would result in a painter who should be regarded as Raphael's superior. To this end Michelangelo supplied Sebastiano with drawings for a mural which he (Sebastiano) was to paint for a Roman church (S. Pietro in Montorio) and for two altarpieces. The second of these – the *Raising of Lazarus*, now in the National Gallery in London – was painted in direct competition with Raphael, whose contribution was the *Transfiguration*, now in the Vatican. It is a fact that Raphael's picture was finally preferred, though his premature death at the critical moment was probably a contributory factor.

Michelangelo's unwillingness on this occasion to come out into the open, and his corresponding readiness to intrigue at a distance, were matched by his extreme touchiness in general and by his tendency to imagine that other artists were plotting against him. This side of his somewhat devious character is also seen in the extraordinary interest which he took in his public image, and in the trouble that he went to to impose his version of it on the world. Characteristically, he did not intervene openly. In 1550 the historian, Giorgio Vasari, had published a biography which, though almost extravagantly complimentary to Michelangelo, did not entirely please him. He therefore engaged a young pupil, Ascanio Condivi, to write what would now be called the official biography, and this was published only three years after Vasari's (1553). At rising eighty, Michelangelo's memory for facts was still good, so that

Condivi's book is basically sound in that respect. But the great man's prejudices had increased with age, and the hatred and resentment which he had felt in his youth for artists such as Ghirlandajo, Bramante and Raphael had lost nothing in intensity, despite the fact that these three were long since dead. Nevertheless the manoeuvre worked. Michelangelo's picture of himself as written by Condivi has remained the official image, and one which it is difficult to think away.

Michelangelo's prejudice is seen at an early stage of Condivi's narrative in the playing down of his training as painter. We can see from Michelangelo's surviving studies after frescoes by Giotto and Masaccio that his training must have been quite thorough. But Condivi went out of his way to minimize it. He slurred over Michelangelo's apprenticeship as painter to Ghirlandajo (causing Vasari, in his second edition, to take the exceptional step of actually printing the contract). Michelangelo probably quarrelled with Ghirlandajo for personal reasons, and he may have felt that Ghirlandajo delayed him from following his preferred métier as sculptor. The resulting implication in Condivi that Michelangelo was virtually an amateur in painting naturally makes the miracles of the Sistine ceiling seem even more miraculous.

It is nevertheless not in dispute that it was as sculptor that Michelangelo had his first overwhelming success. This came with the unveiling of the *David* in the summer of 1504. This colossus, carved from a block which other sculptors had botched or not dared to touch, was universally regarded as a miraculous achievement. From now until the end of his very long life, exactly sixty years later, Michelangelo was the most famous artist in Italy. He was seen as a paragon, to whom any undertaking could be entrusted provided only that it seemed impossible. What in fact *was* entrusted to him was a painting of a battle scene – the *Battle of Cascina* – for the great hall of the Florentine republic. Michelangelo seems to have got no further than the full size cartoon. Though this was immensely admired at the time, and immensely influential, it soon fell to pieces, though its appearance is known from Aristotele da Sangallo's small copy (No. 4). Possibly to prepare himself for this undertaking Michelangelo painted at this

time the only easel picture which survives and which is attributed to him in a document dating from his lifetime. It was the *Holy Family* for the young Angelo Doni (No. 3).

The battle cartoon, we know, had been executed in rivalry with Leonardo, and in the Doni picture Michelangelo seems almost to have set himself to ignore the innovations in painting which Leonardo was making at that time. In works such as the Mona Lisa, for instance, Leonardo had developed a visual approach to painting, softening the outlines and reducing the local colours, in what may be seen as one of the first steps towards Impressionism. In contrast to this Michelangelo's picture, brilliant as it is in execution, looks old-fashioned. In accordance with his opinion that painting should resemble sculpture it is conceptual rather than visual. All the forms are equally, almost blatantly, distinct, and all the colours bright, with no relation between them. In addition, the forms have been fitted so ingeniously into the circular form that they have become distorted in the process. This may not be obvious at a glance, but it is clear if we imagine St Joseph's attitude if the Virgin Mary were removed. The group, in fact, looks as though it were seen from very close quarters in a convex mirror. Of the very few other surviving easel pictures which have been attributed to Michelangelo the unfinished *Entombment of Christ* (No. 6) in the National Gallery has the best claim to being his work. Slightly less likely is the so-called *Madonna of Manchester* (No. 5), in the same collection and likewise unfinished. The attribution to Michelangelo of both of these has frequently been disputed.

Michelangelo's experience as sculptor and his predilection for sculpturesque painting are also very evident in his first major wall paintings which survive, namely the Sistine ceiling. Condivi would have it that the commission was the result of a plot by Bramante, the architect who was then starting to rebuild St Peter's and the Vatican. It was, Condivi adds, hatched in the unholy hope that Michelangelo would make a mess of the job, or would be shown up as an inferior painter to Raphael (who had, incidentally, not even arrived in Rome at the time). In either case it would divert him from the tomb of Pope Julius which is what Michelangelo most wanted to do. The facts are different. What Bramante told the Pope was that he did not think Michelangelo would agree to paint the ceiling. As to the tomb, it is likely that the Pope had turned against the idea of Michelangelo's working on it without any prompting from Bramante. It looks very much as though the ceiling was simply a means of occupying Michelangelo, whose services the Pope did not want to lose. From the point of view of posterity the most important factor is that the ceiling became in Michelangelo's eyes a kind of substitute for the tomb. It can be seen as an attempt to translate the sculpture and architecture of Michelangelo's first project for the tomb of Pope Julius into terms of painted decoration. Both included a series of massive enthroned prophets, interspersed with male nudes.

In all of Michelangelo's major projects, whether as sculptor or painter, the pattern of his procedure is constant. He starts big and gets bigger. He himself said that his first idea for the Sistine ceiling consisted of a series of figures of the twelve apostles in the roughly triangular curved areas where the vault sweeps down between the windows. He planned a pattern of panels filled with ornamentation for the rest of the surface. There are original sketches for this stage in the British Museum and at Detroit. When Michelangelo told the Pope that he had decided on second thoughts that this would give a poor effect and the Pope asked why, Michelangelo replied with a characteristically evasive joke – 'because the Apostles were themselves poor'. He claimed that the Pope then gave him liberty to paint what he liked, and took full advantage of this to evolve an entirely different and much more ambitious scheme. The side walls of the chapel had been decorated by a team of artists from Florence and Umbria about a quarter of a century before. On one side were scenes from Christ's ministry, and on the other episodes from the Old Testament which were considered to prefigure the ministry scenes. On to this scheme, whose effect is delicate and restrained, Michelangelo grafted a vast new element – the semblance of an open air temple in which the side walls seemed to be prolonged upwards into huge painted thrones adorned with medallions, painted sculpture and sup-

porting figures. Down the centre he painted a series of representations of the earliest history of the world, from the *Creation of the Sun and Moon* down to *Noah's Flood*, peopled with a race of sublime and gigantic heroes whose effect owed more to the magnificence of ancient Rome than to any previous Christian art. This scheme in itself would have been enough to crush the delicate existing decoration of the chapel, and produce a discordant effect on the whole. But as the work progressed Michelangelo threw even his own earlier work out of scale. The figures got bigger and bigger, and as the actual space naturally remained the same there had to be fewer and fewer figures.

In these days of mass tourism the visitor is obliged to enter the Sistine Chapel from a side door. But the main door is on the short wall facing the altar (as at St Peter's, which is parallel to it, the liturgical 'east' end of the Sistine Chapel in fact faces west). As Michelangelo worked in the reverse order of the chronological sequence of the biblical events he was portraying, he started (with the Noah scene) over the entrance and ended (at the altar wall) with the Creation. In this way the largest figures are at the far end of the ceiling when one enters the chapel, and though this does have the practical effect of compensating for distance, the root cause is likely to have lain deeper. Michelangelo's ideas were getting more grandiose all the time.

He started work on 10 May 1508, though only on the sketches and cartoons while the scaffolding was being erected and technical preparations made. Michelangelo reckoned at first with employing assistants, and he admitted to having technical trouble with the fresco process at the beginning. When this was cured he told Condivi that he dismissed his assistants and carried out the whole of the gigantic task singlehanded. Nevertheless, he certainly had help in the more mechanical things. His mention in a letter of 'terrific activity' in January 1509 probably means that by then he was already painting. He reported that he had finished the first half – from the entrance to roughly the middle of the chapel – by the middle of August 1510 when the Pope left for Bologna. At this time the scaffolding for the first half appears to have been removed, and Michelangelo's work exhibited.

Condivi says all Rome flocked to see the marvel, and he makes the astounding claim, in full seriousness, that at this stage the archvillain, Bramante, intervened again and tried to get the job of painting the other half of the same ceiling for Raphael.

The second section of the ceiling was unveiled on the Feast of the Assumption (15 August) a year later and the whole reported as finished just over a year later still – on 31 October 1512. This third section was almost certainly the lunettes around the ends and sides of the chapel. The two on the altar wall were destroyed by Michelangelo himself when he came to paint the *Last Judgement*.

Michelangelo left no statement regarding the theological interpretation of the ceiling, and in recent times many different theories have been advanced, mainly contradictory and frequently far-fetched. However, the general theme is clearly mankind's fall from grace and the promise of redemption. The scenes of the Creation on the crown of the vault tell the story of man before the institution of the law by Moses. The latter was already illustrated in the existing frescoes on the south wall. Michelangelo then continued the thread of the story with his prophets (who foretold the coming of Christ to the Jews) and the sibyls (who foretold it to the Gentiles) and with his genealogy of Christ in the lunettes. This led, doctrinally, to Christ's ministry (already existing on the north wall). In the four large, roughly triangular areas at the ends Michelangelo painted four special acts of grace in the history of the Jewish people – *David and Goliath* (No. 26), *Judith and Holofernes* (No. 23), the *Brazen Serpent* (No. 24) and the *Punishment of Haman* (No. 25). He illustrated further Old Testament scenes in the painted bronze medallions held by the athletes (the so-called *ignudi*) who sit on the top of the thrones of the prophets and sibyls.

The least satisfactory features of the ceiling are the scenes which contain many figures. Michelangelo's inexperience as picture-maker was such that he could not grasp the relation of individual figures to painted space – could not suggest that the ground around them receded continuously. This becomes clearer if we consider his fresco of the *Flood* (No. 114), as being the one which contains the most figures. This was the first of

the scenes to be painted on the ceiling, and in it Michelangelo seems to be harking back to the type of composition which he had used in his Battle cartoon. Yet if we compare the *Flood* as a whole with a work of Raphael's such as the *School of Athens* Michelangelo's fresco appears crude. The innumerable felicities of Raphael's pictorial composition – the incredible mastery whereby each of his many figures has its own place in space yet blends with all the others – is beyond Michelangelo. Where he scores over Raphael, however, is in the pathos of the individual figures. Something in the human condition, as depicted by him, wrings the heart after four and a half centuries in a way that Raphael does not. Consider, for instance, the young man on the left of the *Flood* who doggedly climbs the steep rock, anxiously looking ahead, while his wife, on his back, glances round at the horrors they have left. Or the epic group in the middle distance, where the elderly man staggers under the weight of his dying son.

It is nevertheless when Michelangelo is able to avoid multi-figure compositions that he achieves, on the Sistine ceiling, his greatest heights as painter. Nothing in art is comparable, aesthetically, with the athletes, though their doctrinal meaning is not clear. Michelangelo had planned a comparable series of young nude men for the tomb of Julius II, and ultimately finished two of them, and roughed out four more. He called them prisoners, and envisaged them as standing in architectural niches in the tomb. The Sistine athletes are seated, and most of them are influenced by the Hellenistic sculpture-fragment called the Belvedere Torso, which Michelangelo is known to have admired. The curves and diagonals of the Sistine athletes are played off in innumerable inventive and fascinating ways against the rectangles of the blocks which they sit on, and of the frames between them. Yet the variety of the poses alone could never move us as these do. For the athletes are not just physically beautiful. Playful, reflective or terrified they are plainly activated by the spirit, and their visual beauty comes about for that reason.

Nor is there anything in art like the four last scenes of the Creation (the *Creation of Adam* (No. 118), *Separation of Earth and Water* (No. 119), *Creation of the Sun and Moon* (No. 120) and *Separation of Light and Darkness* (No. 121)). The small angels who accompany the Almighty cling to him so closely that they and he count as a single unit. Therefore, in the *Creation of Adam* there are effectively only two figures. Before the sublime form of Adam criticism is stunned, and there are no walls or floor or subsidiary figures to detract from him, just a schematic rock and endless space. Similarly it is impossible to describe adequately the elemental, almost abstract force of the last scene of all – the *Separation of Light and Darkness*. The Almighty, foreshortened so violently from below that nearly all his face is concealed, shoots across the opening like a genie released from a bottle. The impression is of force, movement and light. The forms whereby this is conveyed are of little account in themselves.

Just as the first of the Old Testament scenes, the *Flood*, evolved from an earlier work of Michelangelo's, his Battle cartoon, and the athletes from the prisoners on the Julian tomb, so did the Sistine prophets and sibyls. This time it was from the enthroned prophets which Michelangelo planned for the tomb, and of which he executed only one, the Moses. Though this may have been executed after the Sistine ceiling it was certainly planned before it. As with the athletes the attitudes of the prophets and sibyls become more and more complex as the series proceeds and their scale larger and larger. None of the twelve sits back in his throne, and in none is the body arranged symmetrically (Michelangelo had a fierce dislike of symmetry). Joel (No. 92) is more or less frontal, though sitting well forward. Zachariah (No. 81) sits sideways – an extraordinary thing for an enthroned figure to do. The Libyan Sibyl (No. 86) balances herself on her toes and shows us her back. One might think, after this, that the pursuit of the recherché could go no further. But there is still the Jonah (No. 87) to come. In his mighty, convulsive movement away from the whale he leans so far out of his throne that we can see almost all of it. This seems to have been the figure which was most admired at the time, but, as Condivi explains, for a surprising reason, namely optical illusion. As the part of the vault on which Jonah is painted slopes forwards at the top but the upper part of his body is shown as

sloping backwards the portions of him which seem furthest away are actually those nearest the spectator, and vice versa.

In the lunettes and triangles underneath we are in a different world. They are neither heroic nor nude. They are ostensibly ordinary people engaged in what seem to be domestic occupations. But in fact everything about them is mysterious, suggestive and disquieting. Once again Michelangelo realizes his limitations in space composition. No recession is attempted. In the triangles the figures squat. In the lunettes they sit. In both cases against a plain background. The strange looks of some of them, as though too frightened to speak, and of others as though too much crushed by fortune to wish to do so, foreshadow Michelangelo's late style, which starts with the *Last Judgement*.

In the intervening twenty-odd years, most of which he spent in Florence, Michelangelo's art took a surprising turn. In contrast both with the heroic style of most of the ceiling and the late style of the *Last Judgement* his work of the 1520s is remarkable for its elegance. The chief monument in it are the sculptures of the Medici Chapel, together with their architectural setting for which Michelangelo was also responsible. But the elegant style is also seen in the only painting which he did himself at this time, namely the *Leda*, which is only known from copies (Nos. 123a and b). In addition, Michelangelo again started encouraging painters to do pictures from his drawings as he had done with Sebastiano del Piombo. This time the first recipient to be favoured was the Florentine painter, Pontormo, who did a *Venus* and a *Noli me Tangere* from Michelangelo's designs. Subsequently other painters, above all Marcello Venusti, did the same.

In September 1534 Michelangelo, then aged fifty-nine, took up residence in Rome and never again returned to Florence. Under the new Medici tyrant, Alessandro, his native city had become increasingly distasteful, even dangerous, to him. His return to Rome coincided with the death of the Pope, Clement VII, who had already commissioned the *Last Judgement* of him. The commission was confirmed by the new Pope, Paul III, with whom Michelangelo was soon on intimate terms. He did not start to paint the fresco until the summer of 1536. It was finished in 1541. Since he had painted the ceiling Rome had endured the horrors of the Sack of 1527, when German troops rampaged through the city, robbing, raping and destroying. In consequence, the atmosphere of Rome in the 1530s was tragically changed from the spacious days of Leo X when Michelangelo had last been there, and the change is reflected in his painting. He himself had not been in Rome during the Sack, but his own iconoclasm is much in evidence. Just as the scale and dynamism of his ceiling had swamped the delicate earlier decoration of the Sistine Chapel, so now his *Last Judgement* (No. 122), which fills the entire altar wall apart from a few feet at the base (at about 45 ft by 40 ft it is one of the largest paintings in the world) annihilated everything else in the chapel, including Michelangelo's own ceiling.

This time much of the discord comes from the colour. While the ceiling is delicate, almost opalescent shades, there is much harsh blue in the *Last Judgement*. And though Michelangelo was careful to align the divisions between the three main zones of figures with the two superimposed cornices along the side walls the fact that the cornices break off at the altar wall and that the windows on that wall had had to be blocked in to make room for the painting impairs the architectural unity of the chapel. These drastic measures were nevertheless not foreseen.

Like the ceiling the *Last Judgement* started big and then got bigger. An early sketch, now at Bayonne, suggests that the space which Michelangelo originally planned to cover with the *Last Judgement,* though large, was less than half of the altar wall. A later drawing, now in the Casa Buonarroti in Florence (No. 122a), shows that by that time he envisaged filling more than half the wall, but probably retaining his own two lunettes at the top, and leaving vertical strips at the sides, also – very awkwardly – Perugino's frescoed altarpiece of the *Assumption*, which would have cut into the base of Michelangelo's fresco. Only at a later stage still did he plan to cover the entire altar wall with the *Last Judgement* fresco, destroying two of his own lunettes as well as Perugino's fresco.

Even in the preliminary designs at Bayonne and Florence the main figure – of Christ

– is recognizable from his final form in the attitude of Jupiter hurling a thunderbolt. Yet it is probable that, with his dislike of strict symmetry, Michelangelo never intended his Christ to be perfectly central. In the fresco as it exists, he is significantly slightly off centre. In addition, the asymmetry of his pose reflects that of the even bigger figure of Jonah on the ceiling immediately above him, and it conditions the main element in the design of the colossal fresco as a whole. Christ is to the left of centre, and his upraised left arm initiates a diagonal movement towards the bottom right corner of the fresco.

Both Condivi and Vasari speak of the *Last Judgement* as though Michelangelo's main motive was the academic one of introducing as many varied postures as possible. We have seen in the ceiling that Michelangelo's mind does seem to have relished variations of this kind – just as Beethoven throughout his life had a weakness for the variation form in music. Yet at this stage of his life (Michelangelo was in his sixties when he painted the *Last Judgement*) it seems certain that his art went far deeper than mere academic exercises. The expressionist element, present from the start, is here very obviously beginning to take priority over visual beauty. All commentators have noted how the bodies in the *Last Judgement* lack the grace of those on the ceiling, and as usual Michelangelo departs in some ways from tradition. He will have none of the bearded Christ. The Saviour of the *Last Judgement* is beardless. He is also gigantic and middle-aged, the Adam of the ceiling ten years older and running to seed. Adam actually appears again in the *Last Judgement* but is now unrecognizable. The languid demi-god who had been created at a touch of the Almighty's finger has now become elderly and irate (in profile, to the left of Christ) and by a characteristic piece of wry humour Michelangelo had depicted his own head on St Bartholomew's flayed skin.

Though the age of the Counter-Reformation, which was just beginning, led, among other consequences, to an oppressive prudishness, Michelangelo himself disregarded it to the extent of depicting Christ and the other males full frontally nude. In the event, however, even his superhuman prestige did not suffice to get away with it. Such a parade of male genitalia in the Pope's own chapel was considered going too far. The arch-hypocrite, Pietro Aretino, had the audacity to reproach Michelangelo on this score, and subsequently other painters were employed on at least three occasions to paint draperies over the offending parts. Oddly enough, the most outrageous instance of Michelangelo's black humour – the lecher on the right who is being dragged down to hell by his testicles – was not touched, and remains to this day.

The fact that most of the vast number of figures in the *Last Judgement* are imagined as in the front plane, and as clear of the ground – soaring up to judgement on the left or pushed down to hell on the right, while the entourage of Christ and the Virgin are supported on rock-like clouds – meant that Michelangelo had no need to bother about recession. There is virtually none. As usual with him it is the single figures, when one can isolate them, which are the most memorable. We are haunted by the utter despair of the man in the lower right centre who is dragged by demons towards hell, a fiend like a serpent gnawing his thigh. The man covers half his face with his hand as though unable to contemplate the imminent torment (p. 75). And we reel at the almost indecent ecstasy of one of the blessed who soars upwards from the earth in the lower left corner, her eyes shut, her arms tucked close to her body like those of a foetus.

The problem of recession arises again in an acute form in Michelangelo's last paintings – the *Conversion of Saul* (No. 125) and the *Crucifixion of St Peter* (No. 126) in the Cappella Paolina of the Vatican. This chapel is situated between the Sistine Chapel and St Peter's and, as the Pope's private chapel, must always have been difficult of access, as it still is. Partly for that reason and partly because the early commentators, and, by implication, Michelangelo himself, assumed that he was too old at the time (1542–50) to paint (he was in the region of seventy), little attention was paid to the frescoes until comparatively recently. Their rediscovery seems to have led to their being over-estimated and for that reason it may be useful to argue that they are rather less than total masterpieces.

In essence what the subjects called for was precisely what Michelangelo did least well – a large number of figures spread out over an

open landscape. In the event their relationship to it is ambiguous. They are not quite so tightly packed as in the Battle cartoon or the *Last Judgement*, and the main figures in each – St Paul and St Peter – are clearly emphasized by a degree of isolation. But most of the figures appear irrationally related to the space, and the lighting is non-committal. It is, above all, this monotony in the lighting which militates against an overwhelming first impression from these two huge frescoes, and this despite the fact that, in the *Conversion of Saul* at least, violent light is of the essence: St Paul himself said that it dimmed the light of the sun. There is also the mundane consideration that it is difficult to view the frescoes frontally owing to the narrowness of the chapel. When we cease to look at the paintings as a whole, though, and start to read the single figures it is, as always with Michelangelo, a different matter. The many different varieties of anxiety, uncertainty and obsessive fear which we read on the faces of most of the characters do indeed make up an epitome of the later twentieth century.

In the period of just over four centuries since Michelangelo died his reputation as painter has fluctuated. He was never entirely overlooked, but in the eighteenth century his work tended to be minimized by the more refined and enlightened visitors to Rome. The extent of his influence on later painters was a different story. This was indeed widespread for a time, but most of it now seems pernicious. The complex poses which look sublime in the athletes of the Sistine ceiling become far-fetched and even ridiculous in the hands of followers such as Tibaldi or the Fontainebleau masters. In decoration, his example was more fruitful, and the scheme of the Sistine ceiling became for centuries the almost inescapable model for the decoration on a grand scale of a long apartment. Annibale Carracci used it as the basis of his work in the Farnese gallery, which in its turn became immensely influential, and even in the Galerie des Glaces at Versailles some echoes of the Sistine ceiling may still be traced.

As to Michelangelo's technique as painter, his work, as we have seen, was almost entirely in fresco, and though fresco continued to be used in Italy for another century and more its greatest days were over. Michelangelo's one certain surviving easel painting, the *Doni Tondo*, undoubtedly exercised a crucial influence in mid-sixteenth century Florence. But both this, and the vision embodied in his frescoes, ran counter to what, from the standpoint of the next century, seemed the progressive one. This was, of course, the painterly vision, with soft outlines and subdued and mutually related colours. Starting with Leonardo it had been developed on different lines by Correggio and the Venetians, above all Titian. The hard outlines and vivid local colours (often with 'shot' effects of two different ones on two sides of a fold of drapery) which we see in the *Doni Tondo*, or in Bronzino, were the antithesis of this development.

In academic circles the conflict between draughtsmanly, or Antique-oriented painters, and the painterly, or more naturalistic ones, continued to see-saw for three centuries. In the seventeenth and early eighteenth the essence of the controversy continued, with the followers of Nicolas Poussin ranged against those of Rubens. In the nineteenth it was the adherents of Ingres and the Classicists against Romanticism and Delacroix. Michelangelo's standing in these disputes varied from one age to the next. In the eighteenth century he was much less admired within the 'draughtsmen's', or 'Classicists'' party than was Raphael, and by the beginning of the nineteenth he had, so to speak, gone over to the other side. His 'terribilità' endeared him to the Romantics, and the young Delacroix went so far as to pair him with Byron.

The sustained interest in Michelangelo in the present century, to an extent far above that currently taken in Raphael, or, almost, any other artist, seems at least partly due to the extinction of interest in all of the former controversies. Now that no one bothers greatly about the differences between draughtsmanly and painterly painters, or even about classicists and romantics, we are able to regard Michelangelo as Vasari saw him, that is, as a giant who bestrode all the major visual arts – sculpture, painting, drawing and architecture. And this may well prove to be a more enduring assessment of his stature than the intermediate ones.

Catalogue of
the Paintings

All measurements are in centimetres unless otherwise indicated.

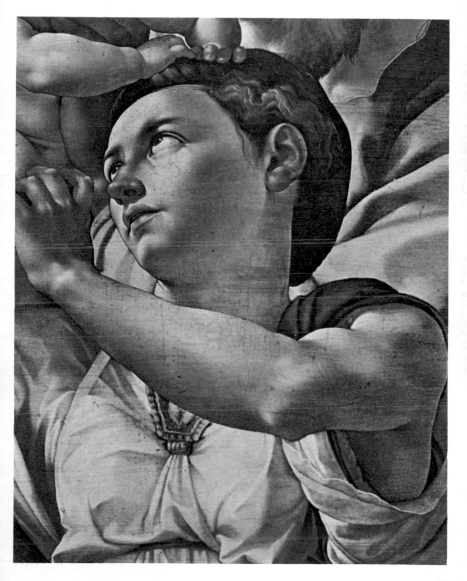

Doni Tondo (No. 3: detail) (p. 11). Michelangelo re-used the pose of the Madonna's head, in reverse, some years later for the Prophet Jonah on the Sistine ceiling (No. 87). A drawing by Michelangelo (Florence, Casa Buonarroti, No. 87a) is sometimes associated with the Jonah but was probably made for the Doni Madonna.

1 The Temptation of St Anthony
(from a print by Schongauer)
Juvenile work.
Lost.

2 St Francis receiving the Stigmata
Painted for San Pietro in Montorio, Rome, during Michelangelo's first residence there, 1494–1501.
Lost.

3 The Holy Family with the Infant St John (the Doni Tondo)
Tempera on panel, circular, diam. 119.
Photo 87a is a preliminary study for the Madonna's head.
Early work.
Florence, Uffizi

4 The Battle of Cascina
A projected decoration for the Palazzo Vecchio, Florence, on which Michelangelo worked in 1504–5. The actual painting was probably never started, and the full-size cartoon is lost. There is a preliminary composition sketch in Florence (Photo 4a) and a copy after the cartoon by Aristotele da Sangallo at Holkham (Earl of Leicester, Photo 4c). A Michelangelo sketch in the British Museum (Photo 4b) is often related to the project. But as it shows horsemen attacking each other, and as it is known that at Cascina only one side had

12

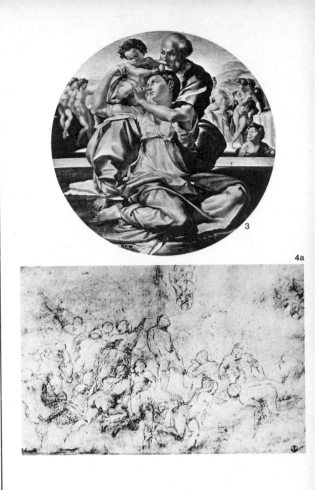

3

4a

4b

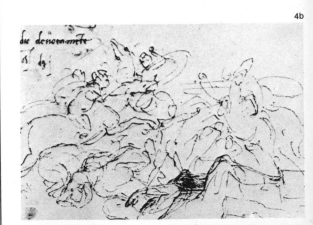

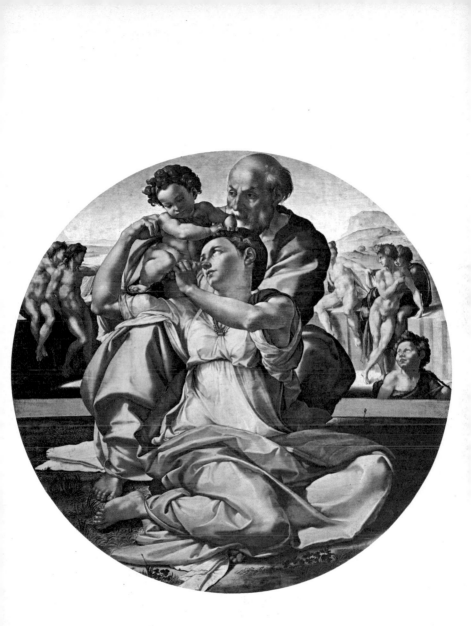

Doni Tondo (**No. 3**). *The young St John the Baptist, seen in the middle distance on the right, seems intended to constitute the link between the Holy Family in the foreground and Paganism in the background.*

horses, it is more probably Michelangelo's sketch-copy of part of the rival cartoon of the BATTLE OF ANGHIARI by Leonardo.

5 Madonna and Child with the Infant St John and Angels
Panel/105 × 76/Unfinished
If by Michelangelo it would have to be before 1500. But the attribution to him is disputed.
London, National Gallery (809)

6 The Entombment of Christ
Panel/161 × 149/Unfinished
If by Michelangelo, which is more likely than not, probably painted at two different times.
London, National Gallery (790)

Doni Tondo (No. 3; detail). The nude youths in the background are usually seen as foreshadowing the Athletes on the Sistine ceiling (Nos. 93–102). But it is likely that they in their turn derive from the shepherds in the background of a tondo of the MADONNA AND CHILD by Luca Signorelli, which is now in the Uffizi.

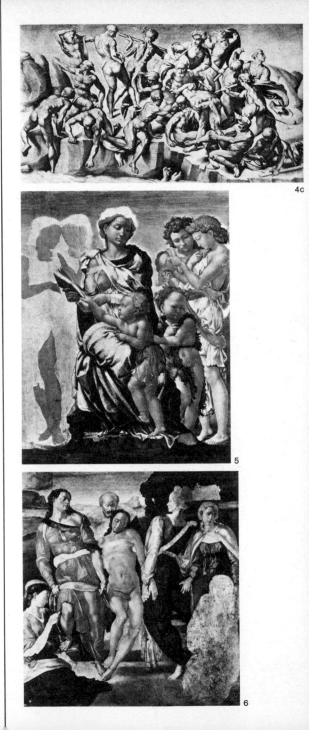

4c

5

6

14

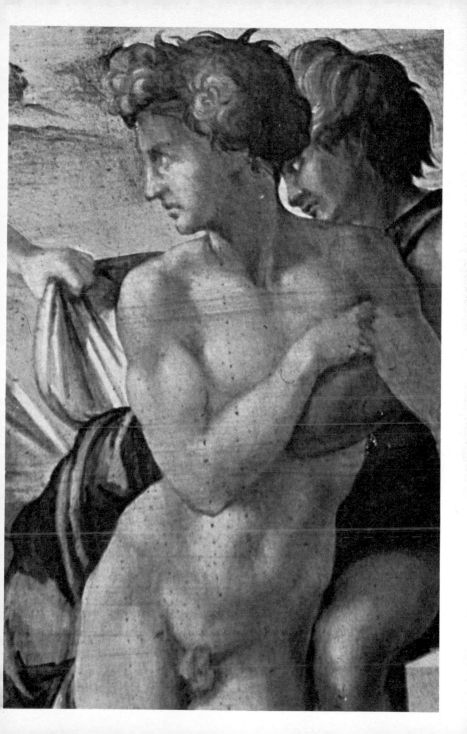

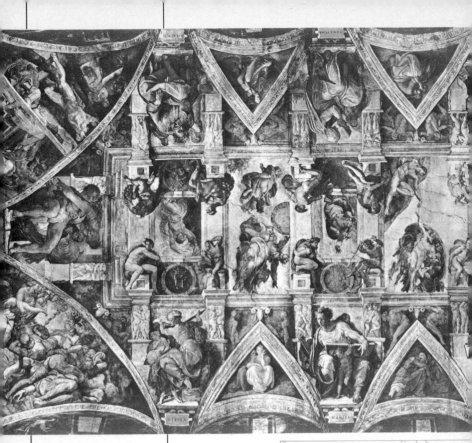

THE SISTINE CHAPEL FRESCOES

THE CEILING

The series of subjects painted by Michelangelo, 1509–12, on the ceiling of the Sistine Chapel (*c.* 13·4m × 40.21m; Rome, Vatican) is listed below. For the exact position of each subject, see the numbered plan given here. For each series of compartments, read in a clockwise direction, starting at bottom right. The titles are based either on the most widely-agreed interpretations or on inscriptions painted by Michelangelo himself, in which case they appear within quotation marks.

16

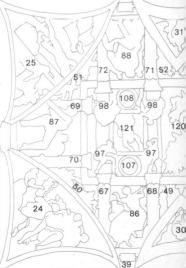

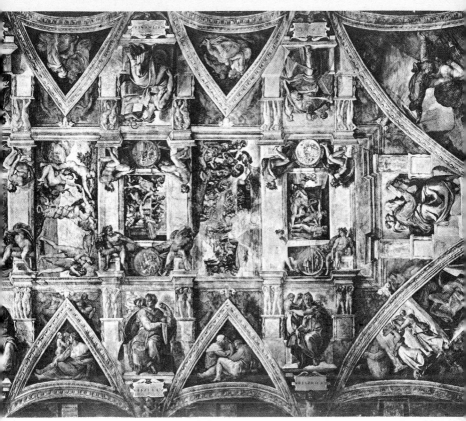

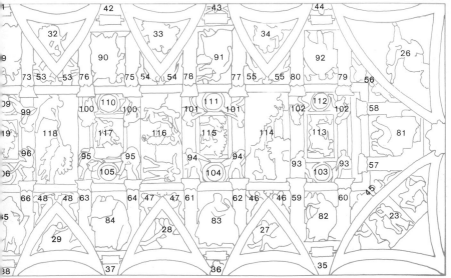

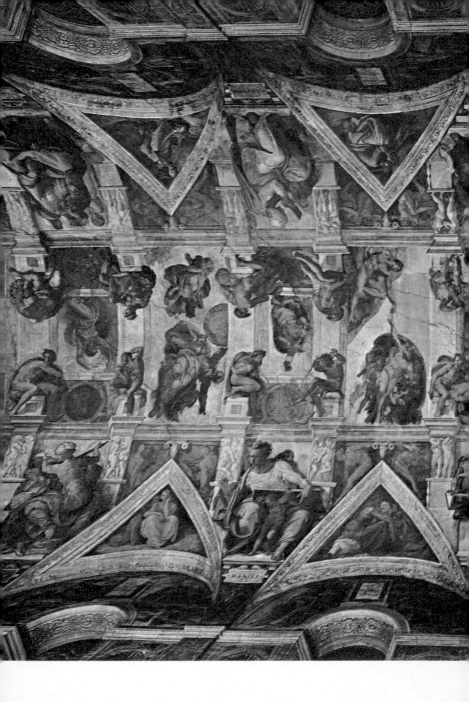

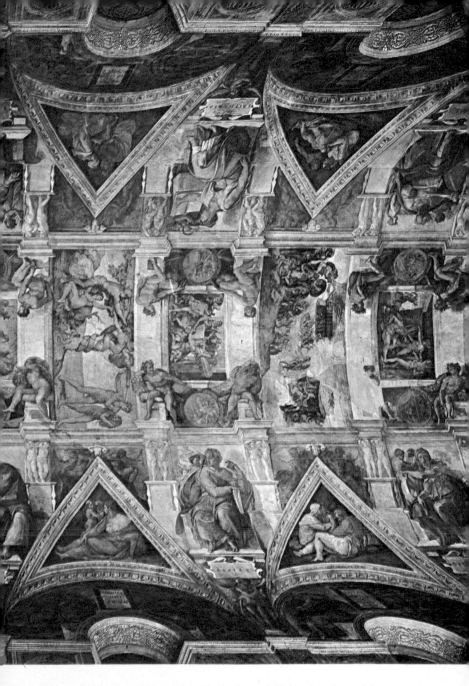

The Ceiling of the Sistine Chapel (*Nos. 7–121*). *The Prophets and Sibyls enthroned around the perimeter may be regarded as an extension upwards of the actual walls of the chapel. But the Old Testament scenes down the centre are not consistent with such an idea.*

The Lunettes, showing the Ancestors of Christ

7 '*Iacob/Ioseph*'

8 '*Azor//Sadoch*'

9 '*Iosias//Iechonias//Salathiel*'

10 '*Ezechias//Manasses//Amon*'

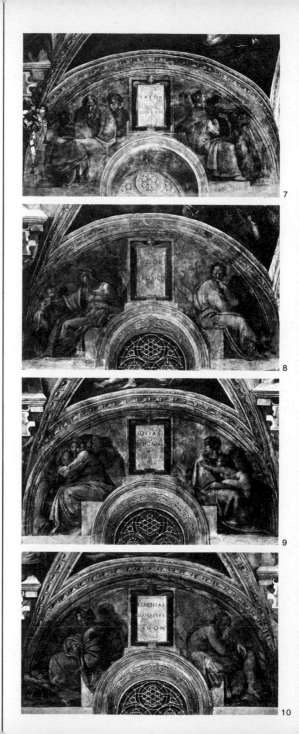

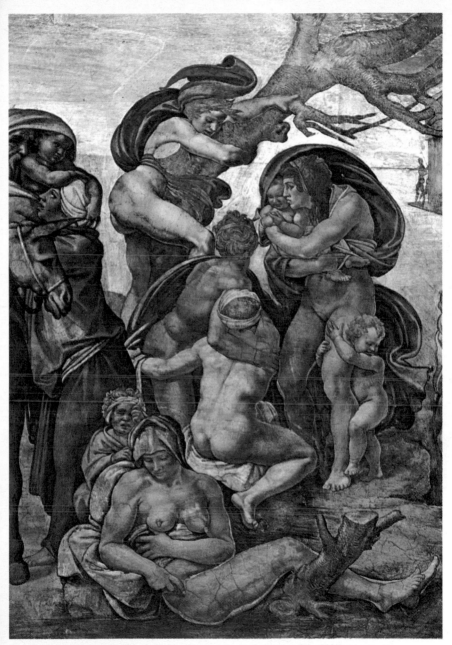

***The Flood** (**No. 114; detail**). Though the Flood is chronologically the last of the Old Testament scenes down the centre of the ceiling it was the one that Michelangelo painted first. Throughout his life he tended to revert to poses he had used before. Some of these recur in the* LAST JUDGEMENT *(No. 122).*

11 *'Asa//Iosaphat//Ioram'*
12 *'Iesse//David//Salomon'*
13 *'Naason'*

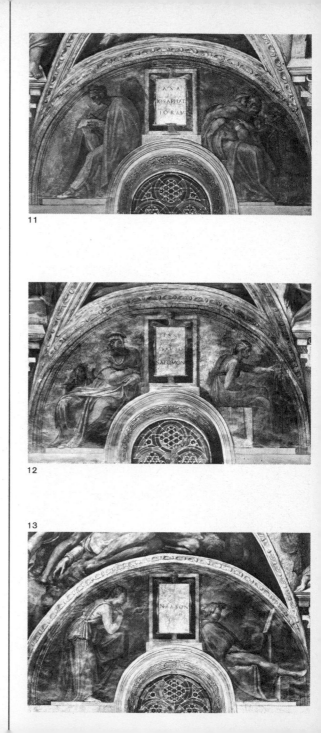

11

12

13

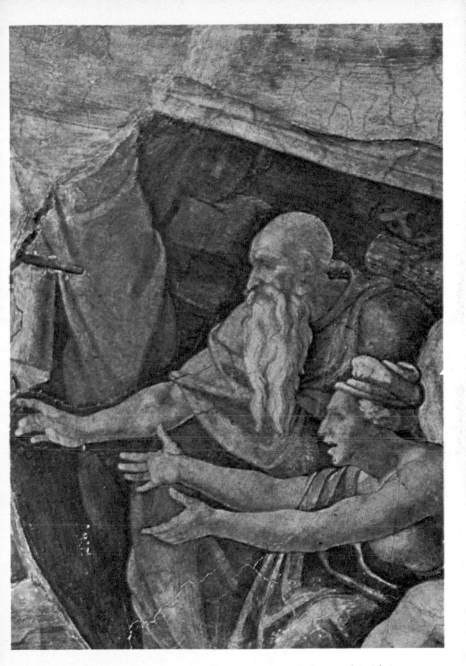

The Flood (*No. 114; detail*). *The woman and the old man are reacting to the drama on their right in which the father supports his dying son.*

14 'Abraam//Isaac//Iacob// Ivdas'
Lost lunette, known through an engraving by W. Y. Ottley (*c.* 1800), after a 16th-century drawn copy, later lost (Photo 14a)

15 'Phares//Esrom//Aram'
Lost lunette, known through an engraving by W. Y. Ottley (*c.* 1800), after a 16th-century drawn copy, later lost (Photo 15a)

16 'Aminadab'

17 'Salomon//Booz//Obeth'

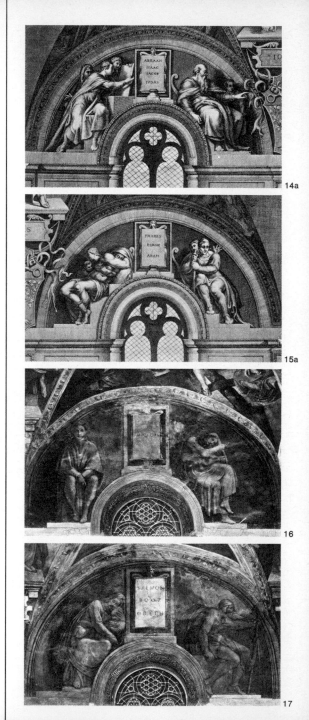

14a

15a

16

17

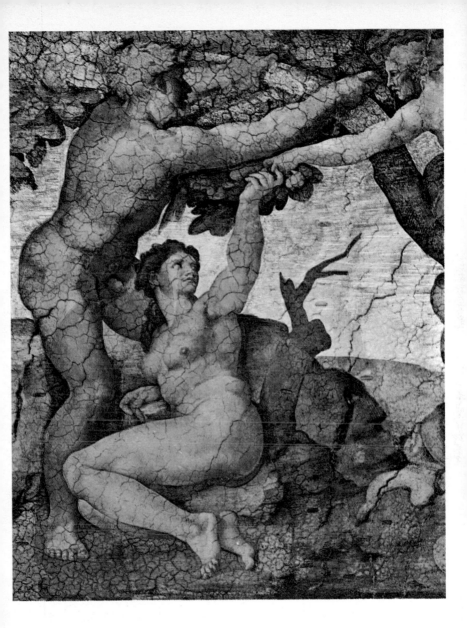

The Fall (No. 116). For once Michelangelo has allotted the more elaborate pose to the woman (Eve) rather than to Adam. Following a tradition already fairly old he has given the serpent a woman's head and bosom.

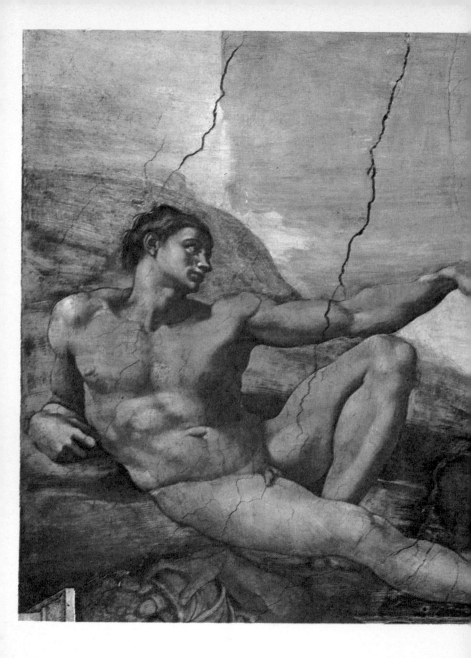

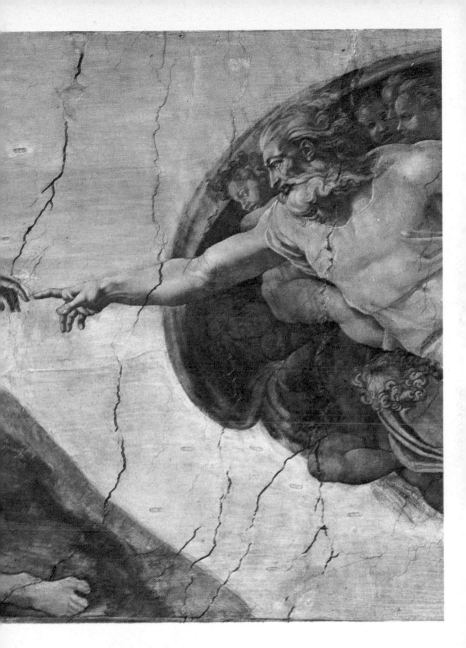

The Creation of Adam (No. 118; detail). *The joins in the plaster, which are still visible, show that the Adam, the most famous figure on the ceiling, took Michelangelo no more than three days to paint.*

18

19

20

21

22

23

24

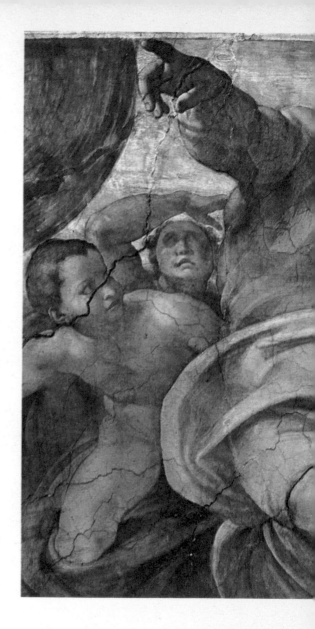

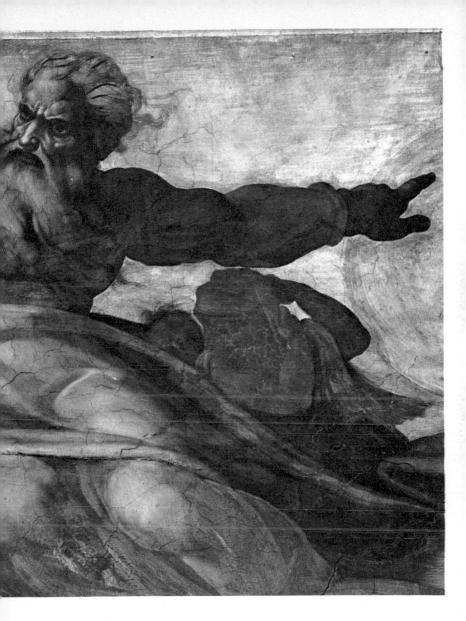

The Creation of the Sun and Moon (*No. 129; detail*). *The dynamic figure of Jehovah is similar in type to Michelangelo's sculpture of Moses, most of which was carved slightly later than the Sistine ceiling.*

31

25 The Punishment of Haman
Fresco/*c.* 585 × 985/1511
Photo 25a shows a
stupendous study of a nude
which bears an obvious
relation to the figure of Haman
(Paris, Louvre). On the same
folio there is a study of an
arm and another of a bearded
figure.

26 David and Goliath
Fresco/*c.* 570 × 970

The Tympana

27 Josiah with his Parents

**28 Hezekiah just suckled by
his Mother**

**29 Asa consoles his Father.
His Mother drowses**

**30 The young Jesse with his
Parents**

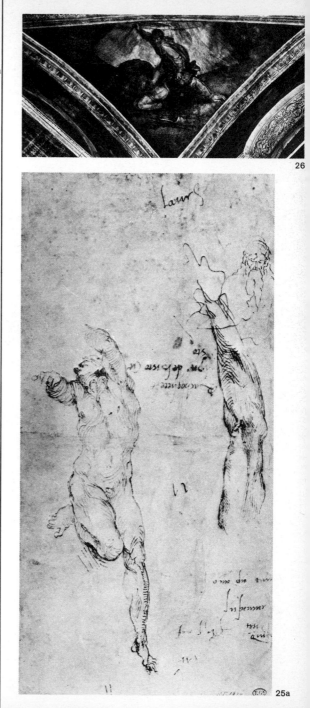

26

25a

25

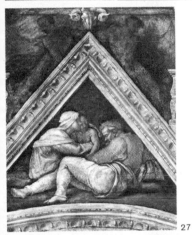

27

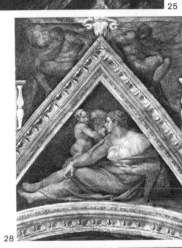

28

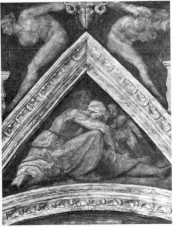

29

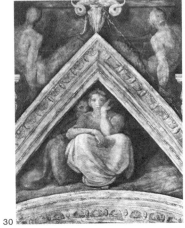

30

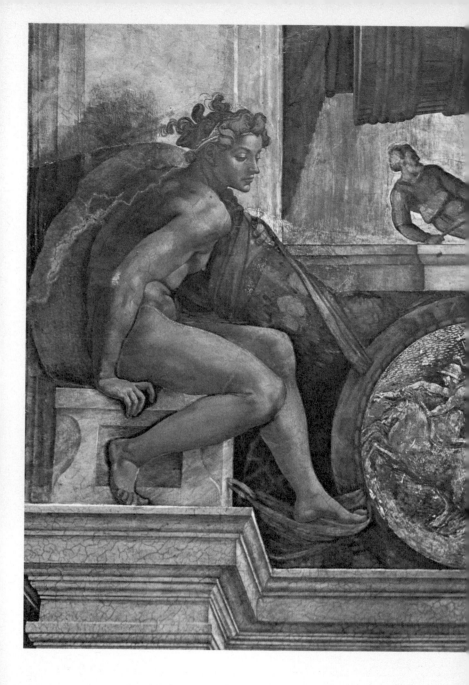

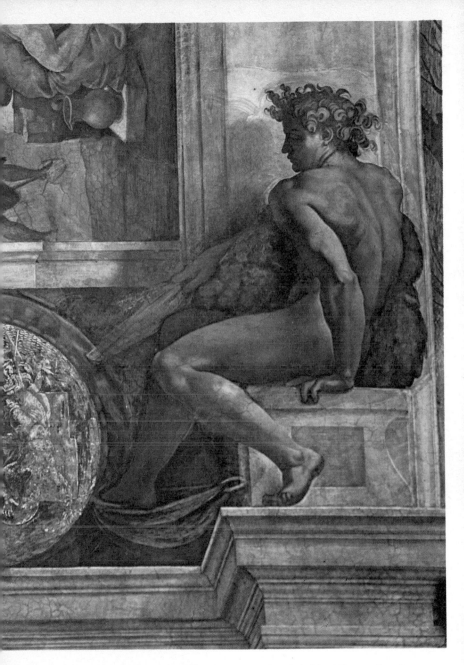

Pair of Athletes above the Prophet Joel (*No. 102*). *These are two of the first of the Athletes on the ceiling. Their poses are already subtly contrasted. Later the attitudes will become more elaborate and the bodies bigger.*

31 The young Solomon helps his Mother who is cutting a Length of Cloth

32 Rehoboam with his Mother. In the Background, Solomon

33 The young Ahazia with his Mother. Joram with another Son

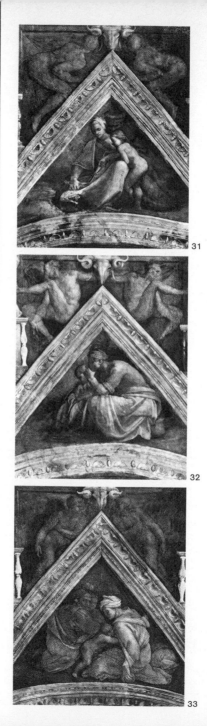

31

32

33

Athlete above the Eritrean Sibyl (No. 101; detail). Part of the second quartet of Athletes (out of five) but already the physical beauty is tinged with a kind of neurosis which will become more marked later.

34 The young Zorobabel with his Parents

The Putti bearing Inscriptions below the Prophets and Sibyls

The inscriptions on the simulated marble tablets are given in brackets after the titles.

35 Putto below the Delphic Sibyl
('Delphica')

36 Putto below the Prophet Isaiah
('Esaias')

37 Putto below the Cumean Sibyl
('Cvmaea')

38 Putto below the Prophet Daniel
('Daniel')

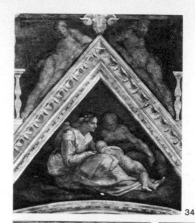

34

35

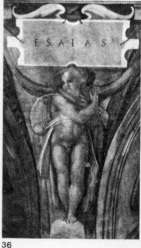

36

37

38

Athlete above the Prophet Jeremiah
(No. 98; detail) (pp. 40–41).
Perhaps the most beautiful of all the Athletes. Such is the equilibrium of the effect that it is difficult to realize how far-fetched the pose really is, with the legs tying themselves up in knots.

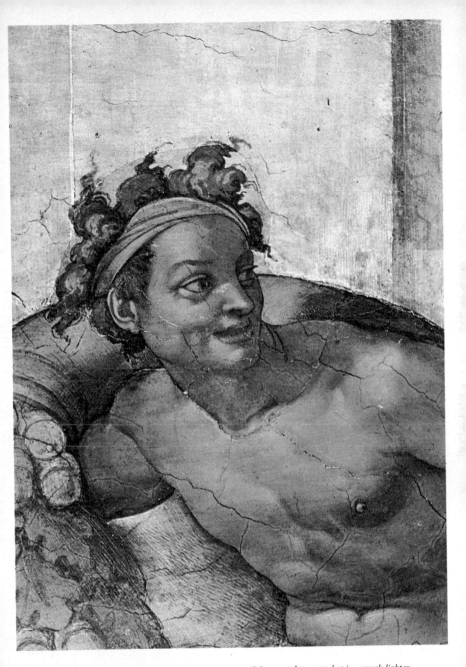

Athlete above the Prophet Isaiah (No. 94; detail). *Another of the second quartet, but in a much lighter and less disquieting vein than the preceding one.*

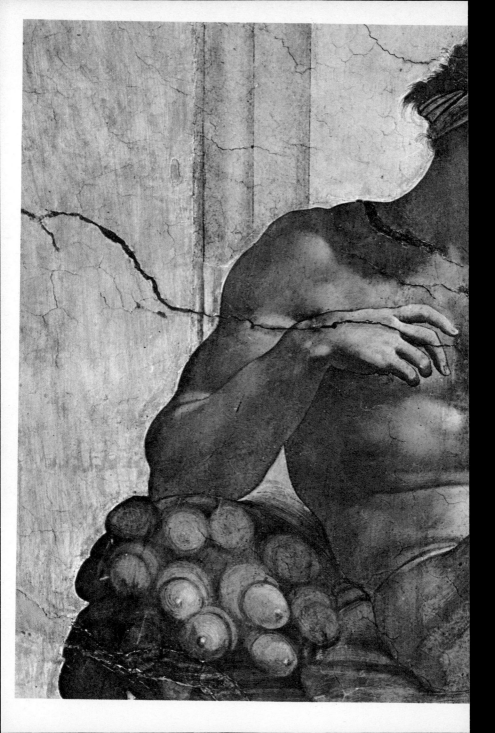

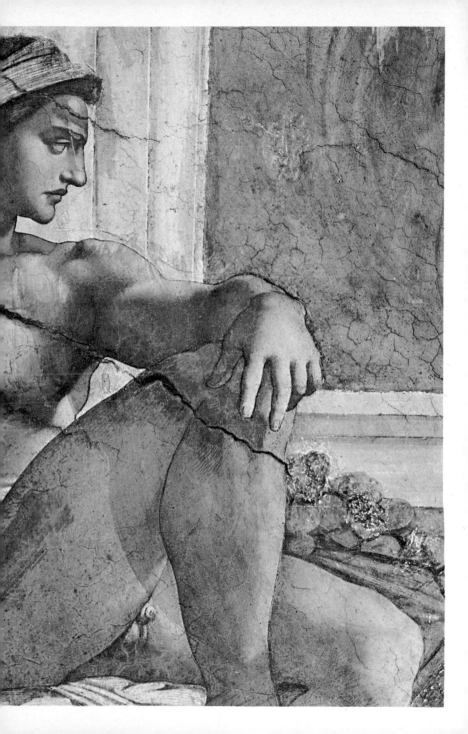

39 Putto below the Libyan Sibyl
('Libica')

40 Putto below the Prophet Jeremiah
('Hieremias')

41 Putto below the Persian Sibyl
('Persicha')

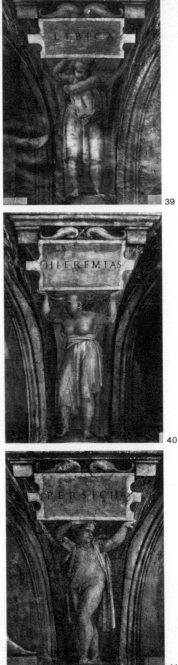

39

40

41

Athlete above the Persian Sibyl (No. 99). One of the more terrified (and terrifying) of the series. The pose shows particularly clearly the influence of the Hellenistic marble known as the BELVEDERE TORSO, *which Michelangelo much admired.*

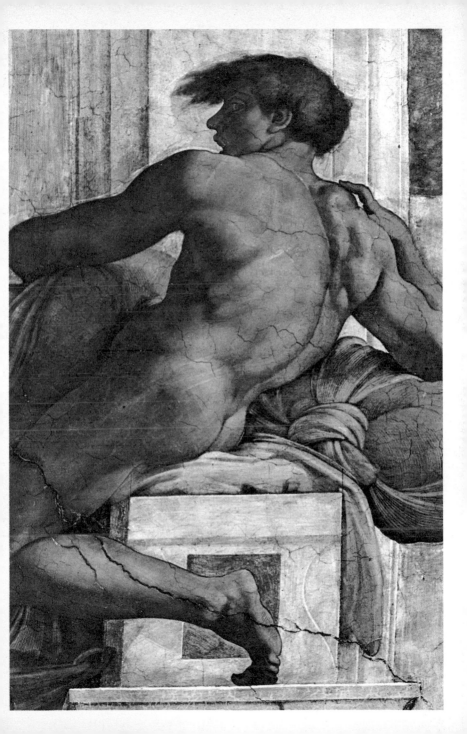

42 Putto below the Prophet Ezekiel
('Ezechiel')

43 Putto below the Eritrean Sibyl
('Erithraea')

44 Putto below the Prophet Joel
('Ioel')

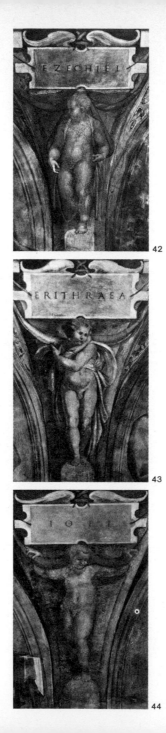

42

43

44

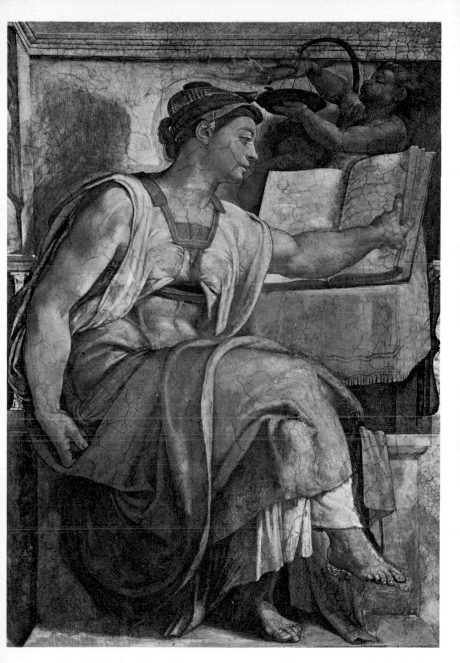

***The Eritrean Sibyl** (No. 91)*. *One of the earlier ones in the series. Intended as a young woman, the huge body could be either male or female.*

The Simulated Bronze Nudes

Photo 49a shows a preparatory study which is similar to the left-hand nude (Cleveland, Museum of Art), but is really for the Athlete on the right above the Prophet Daniel (No. 96)

The Cumean Sibyl
(No. 84). The middle figure of the five above the north wall of the chapel. The massive proportions of the upper half of the body suggest a degree of stability which is belied by the nervous attitude of the legs.

45

50

51

56

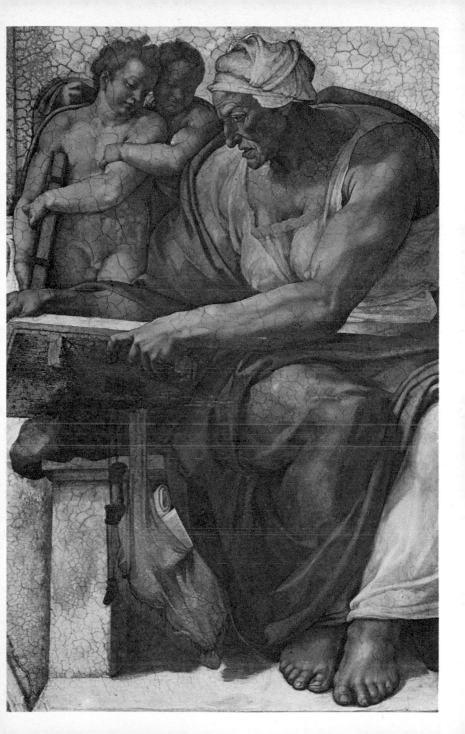

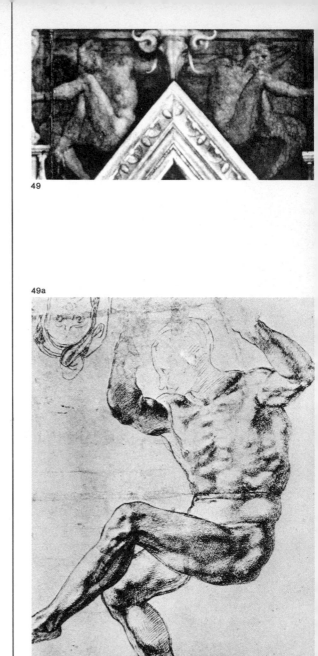

49

49a

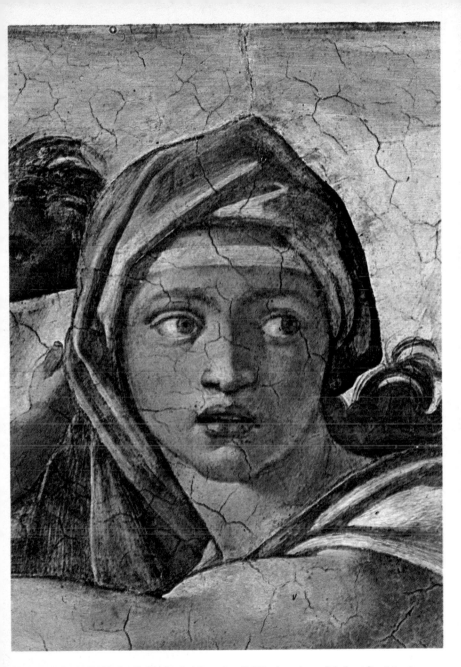

The Delphic Sibyl (***No. 82; detail***). *The head of the earliest Sybil in the series, and the least disquieting in general effect. The beautiful face might be either male or female.*

The Prophet Isaiah (No. 83). *Whatever may be the theological implications of the small wingless angels or putti, who appear with most of the Prophets and Sibyls there is no doubt that aesthetically they fulfil more than one purpose. They provide contrasts both of size and mood, and in this case introduce variety into the pose of the Prophet by distracting his attention.*

65-66

67-68

77-78

79-80

52

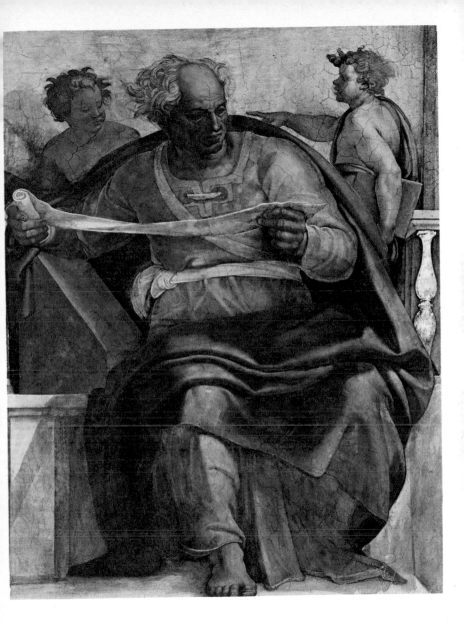

The Prophet Joel (*No. 92*). *Michelangelo was temperamentally opposed to executing portraits of living people, but probably incorporated an element of portraiture into the heads of the prophets. This one has been thought to draw on the features of his rival, the architect, Bramante.*

Prophets and Sibyls (The Seers)

81 The Prophet Zachariah
82 The Delphic Sibyl

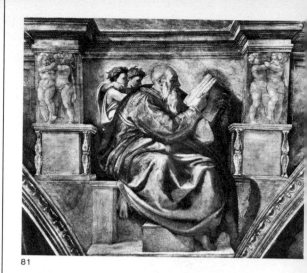

81

82

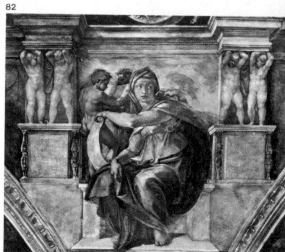

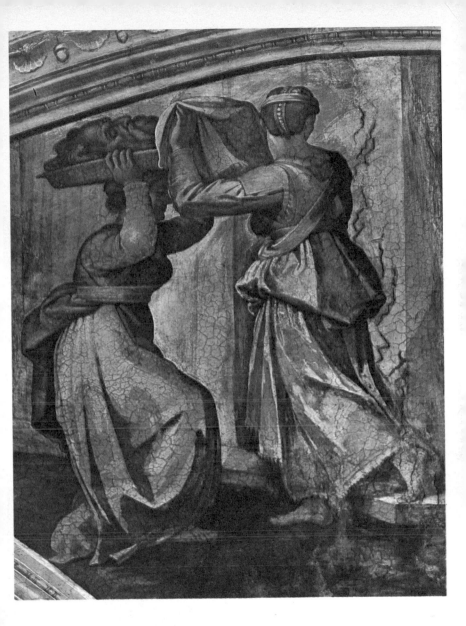

Judith and Holofernes (***No. 23; detail***). *Having done the grisly deed Judith and her maid slink away, leaving the headless corpse of Holofernes on the bed to the right.*

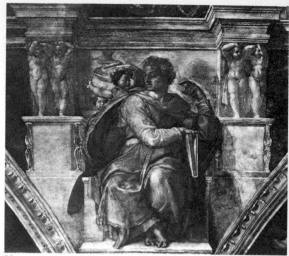

83

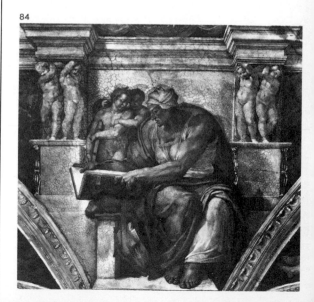

84

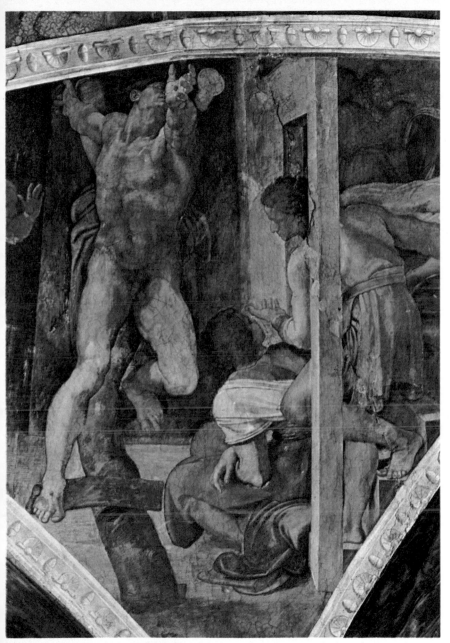

The Punishment of Haman (*No. 25; detail*). *One of Michelangelo's most spectacular feats of anatomical virtuosity. Since Haman's right foot is near the edge of the picture we must assume that his extended left hand actually sticks out into space on the spectator's side.*

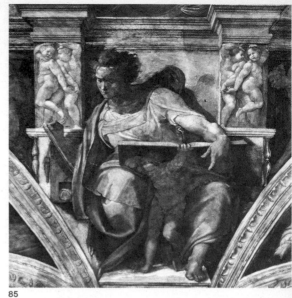

85

86

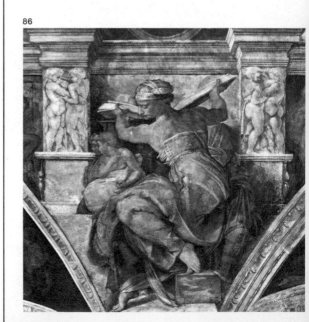

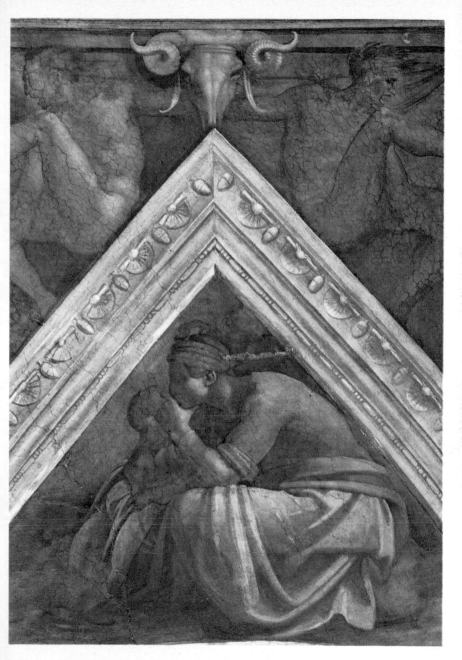

Rehoboam with his Mother (*No. 32*). *It is typical of one aspect of Michelangelo's strange mentality that the figures at the top, which are meant to be sculpture, should be more lively than those in the triangle below which are meant to be real.*

87 The Prophet Jonah
Photo 87a shows a drawing
(Florence, Casa Buonarroti)
which is sometimes associated
with the Jonah. But as it is in
reverse and also in the
technique of Michelangelo's
early period it must in fact be
for the Madonna in the DONI
TONDO (No. 3).

88 The Prophet Jeremiah

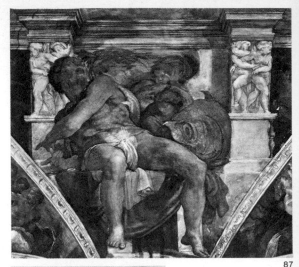

87

87a

88

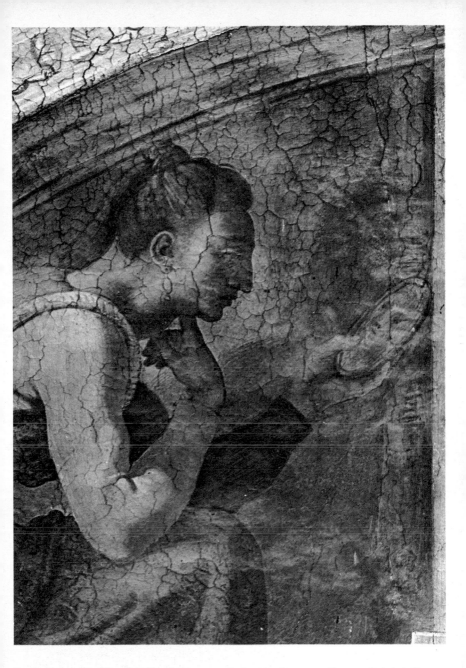

Detail of lunette (No. 13). *A forbidding-looking woman looks at her face in a small mirror which she holds in her left hand.*

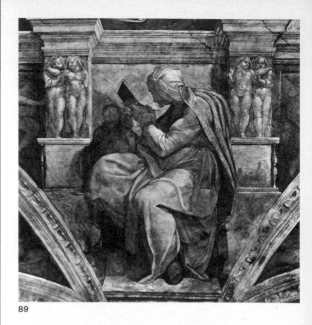

89

90

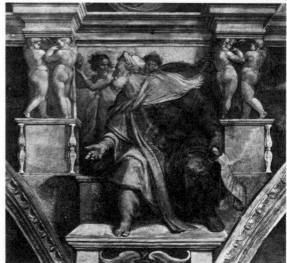

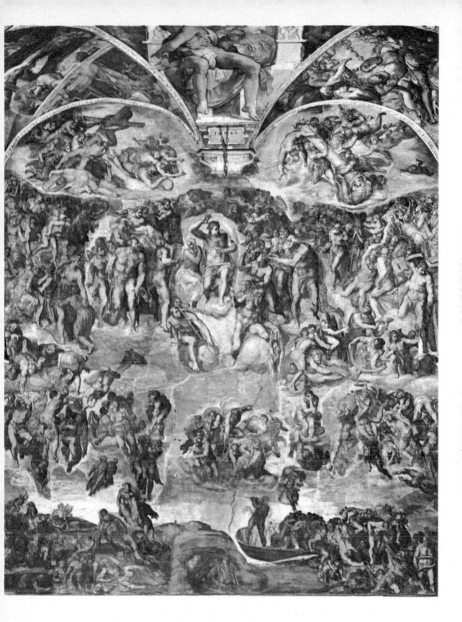

The Last Judgement (*No. 122*). *The spaces between the zones of the figures are arranged to coincide with the architectural entablatures of the side walls of the chapel which adjoin this wall.*

91 The Eritrean Sibyl

92 The Prophet Joel

The Athletes

93 Pair above the Delphic Sibyl

There is a drawing by an unknown artist of the left-hand athlete, which is mostly destroyed, in the Royal Collection at Windsor (Photo 93a).

94 Pair above the Prophet Isaiah

95 Pair above the Cumean Sibyl

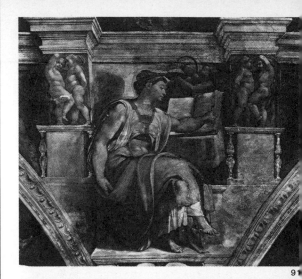

91

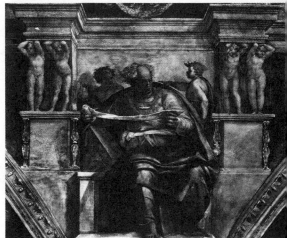

92

The Last Judgement (No. 122A; detail) (pp. 66–7). Angels manoeuvring the column of the Passion. Like all the angels in the Sistine frescoes they have no wings and therefore give an impression more of swimming than of flying. Top right.

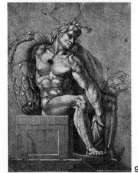

93a

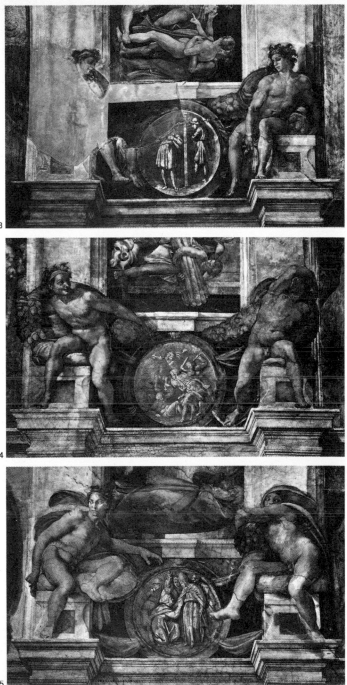

93

94

95

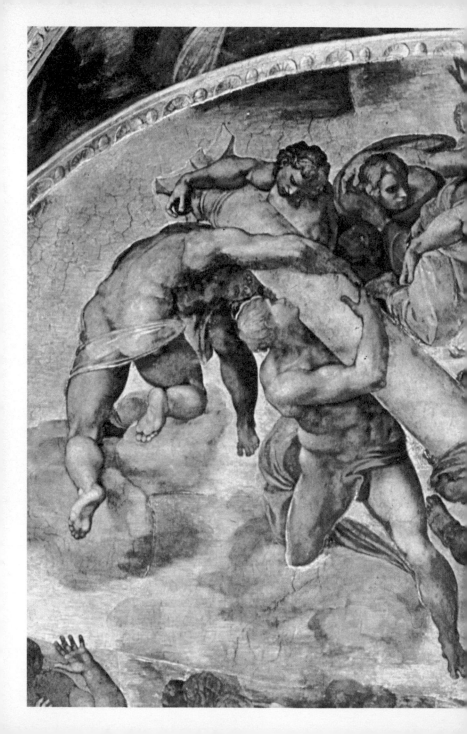

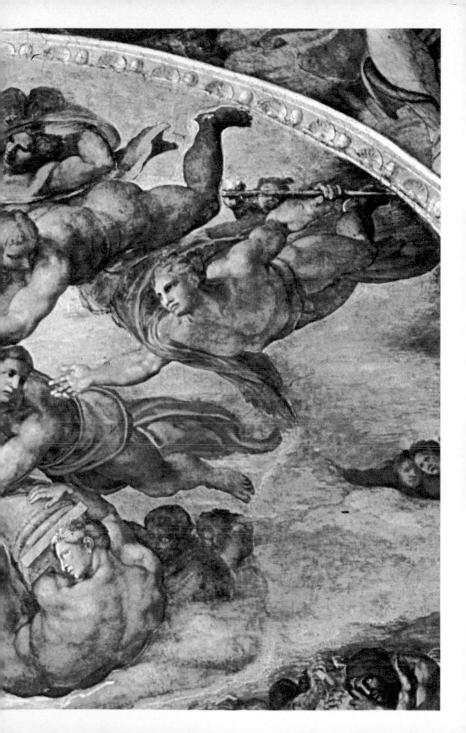

96 *Pair above the Prophet Daniel*

97 *Pair above the Libyan Sibyl*

98 *Pair above the Prophet Jeremiah*

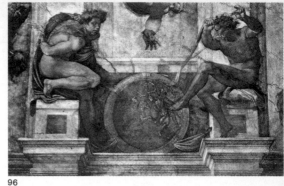

96

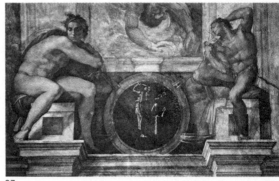

97

98

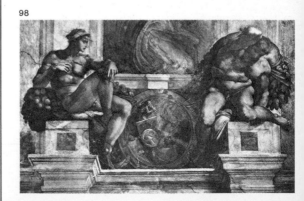

***The Last Judgement**
(**No. 122B; detail**). The
Virgin, trying to intercede with
Christ, who is nearly twice her
size, appears cowed by him.
Upper centre.*

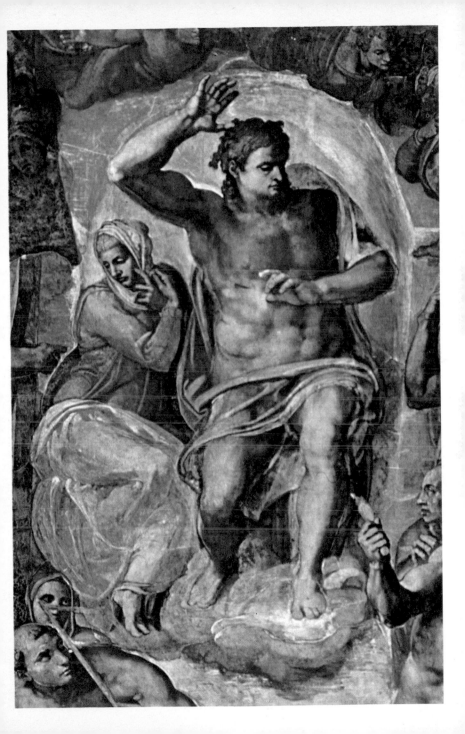

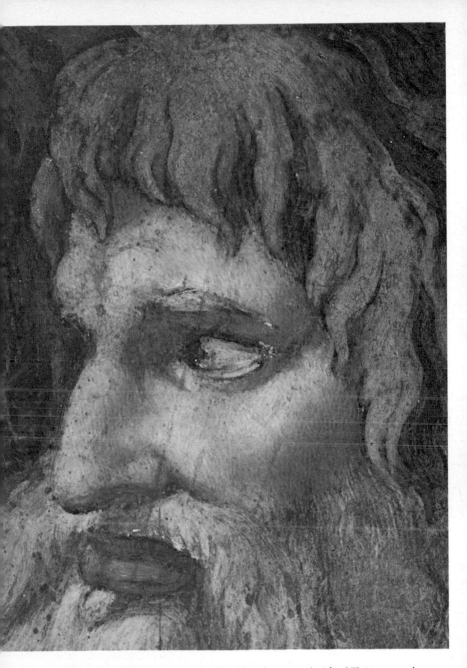

The Last Judgement (No. 122B; detail). *Two of the blessed, to the spectator's right of Christ, appear almost as apprehensive as the damned.*

99 Pair above the Persian Sibyl
A study for the right-hand athlete (99a) is preserved in Haarlem, — Teilers Museum.

100 Pair above the Prophet Ezekiel

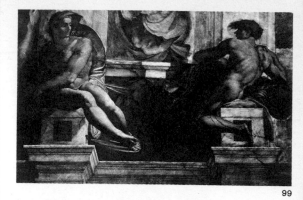

99

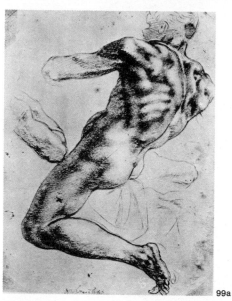

99a

100

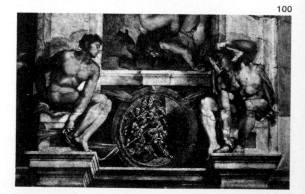

The Last Judgement (No. 122B; detail). In masochistic mood Michelangelo paints his own features on the flayed skin of St Bartholomew. Diagonally down from Christ's left foot.

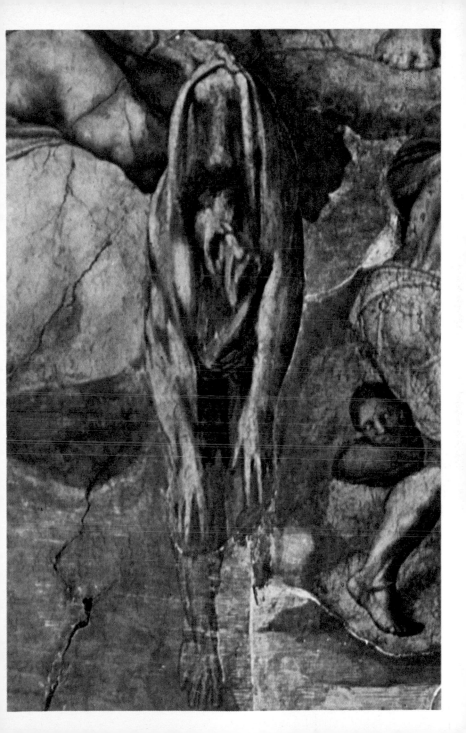

101 Pair above the Eritrean Sibyl

102 Pair above the Prophet Joel

The Simulated Bronze Medallions

These are between the pairs of athletes.

103 Joab kills Abner

104 The Death of Uriah

105 David kneels before the Prophet Nathan

106 The Death of Absalom

107 The Sacrifice of Abraham

108 Elijah in the Chariot of Fire

109 Unpainted

110 The Destruction of the Tribe of Ahab

111 Jehu has the Image of Baal destroyed

112 The Corpse of King Joram is thrown from the Chariot by Bidkar

The Last Judgement
(*No. 122F; detail*). *Although he has not yet quite reached hell this one has already abandoned all hope. Second zone from bottom, right centre.*

101

102

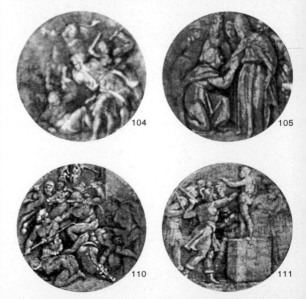

104

105

110

111

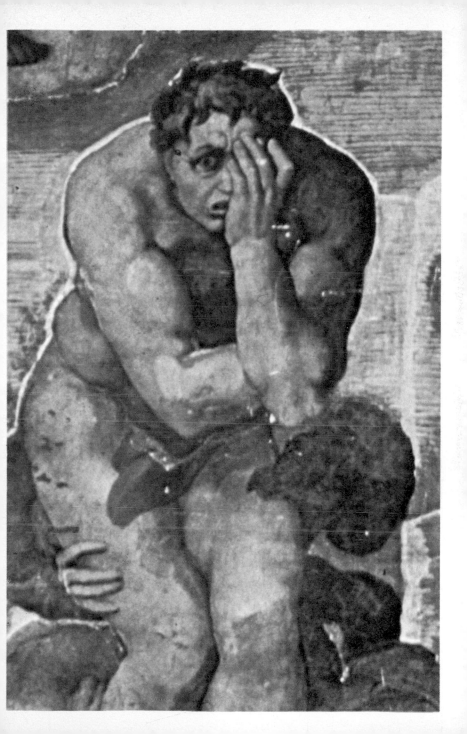

The Biblical Stories

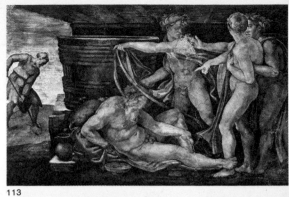

113

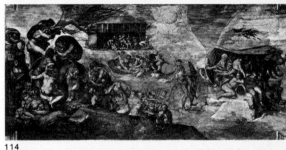

114

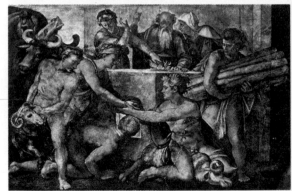

115 116

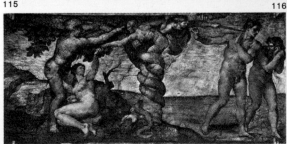

**The Last Judgement
(No. 122D; detail)**. *One of
the elect flies upwards. Second
zone from the bottom, left
centre.*

**The Last Judgement
(No. 122C; detail) (pp. 78–9)**.
*St Catherine and St Sebastian
show the instruments of their
martyrdom – part of a wheel
and some arrows. Right
centre.*

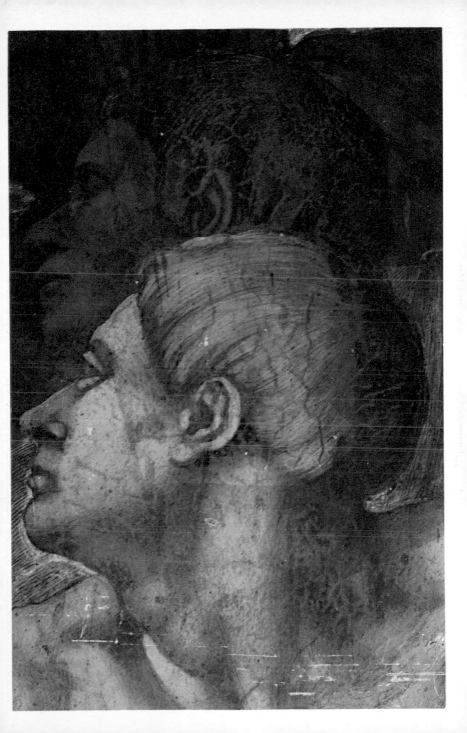

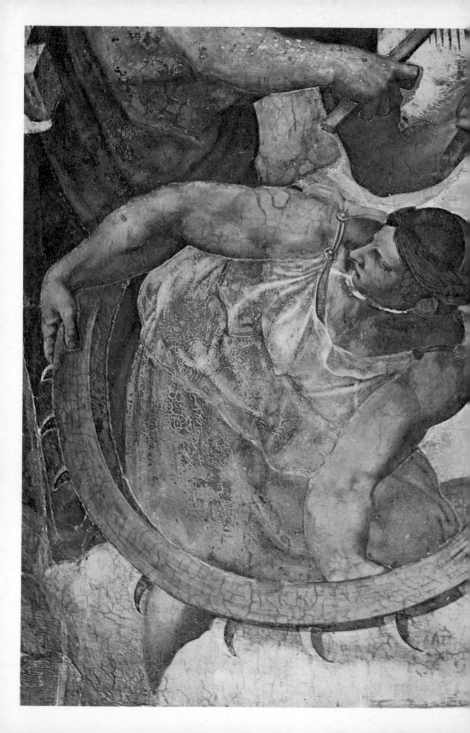

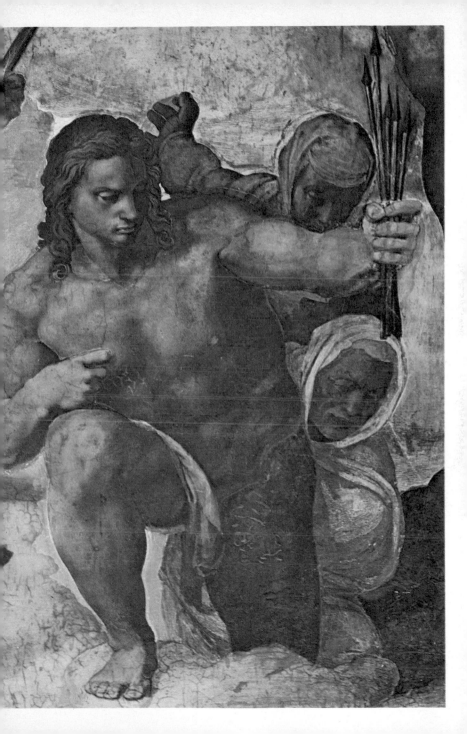

117 The Creation of Eve

118 The Creation of Adam
A preparatory study for the
figure of Adam is in London,
British Museum (Photo
118a).

*119 God separating the
Waters from the Earth*

The Last Judgement
(*No. 122E; detail*). *The burly
young trumpeter blows a
fanfare, intended, literally, to
awaken the dead. Centre, a
little up from bottom.*

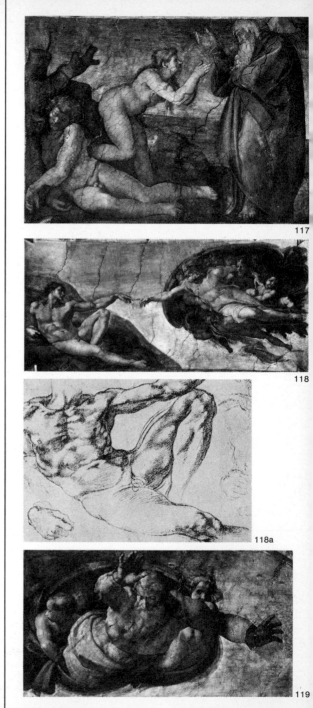

117

118

118a

119

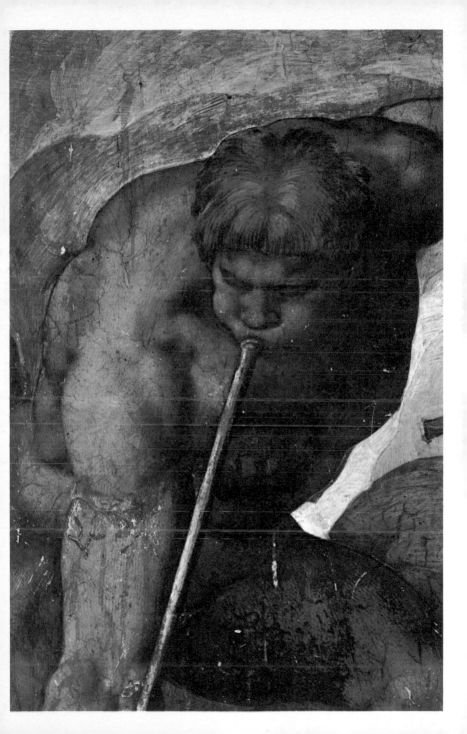

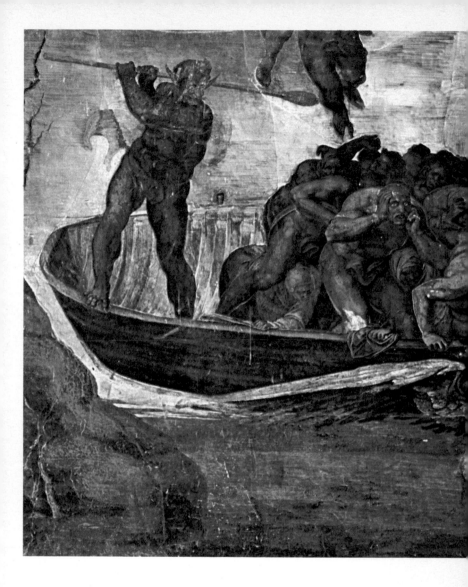

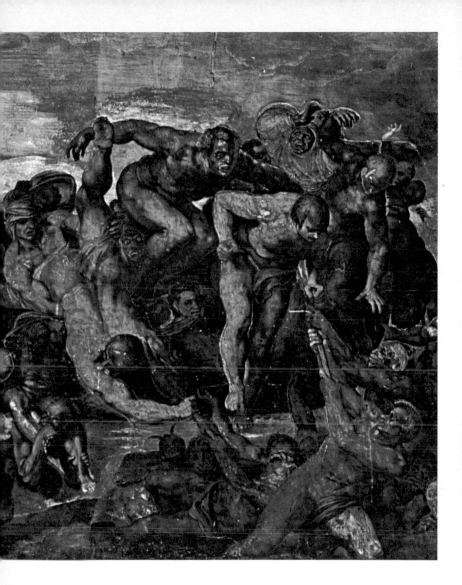

The Last Judgement (**No. 122H; detail**). *Charon ferries the damned towards the infernal regions. Bottom right.*

120 *The Creation of the Sun and Moon*

121 *The Separation of the Light from the Darkness*

122 THE LAST JUDGEMENT

Fresco/1370 × 1220/1536–41
An early sketch for the whole composition is in Florence, Casa Buonarroti (Photo 122a). To make it easier to follow, various sections of the fresco are illustrated separately and listed below.

122A *Top left: angels bearing the symbols of the Passion with a group of the elect.*

122B *Top centre: Christ the Judge, the Virgin, St Lawrence and St Bartholomew.*

122C *Top right: angels bearing the symbols of the Passion and a group of the elect.*

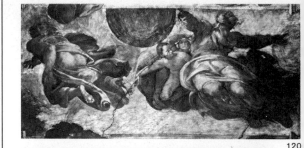

120

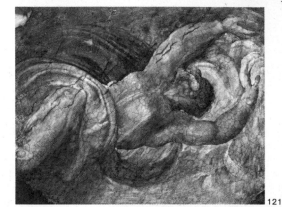

121

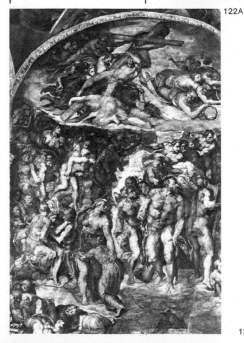

122A

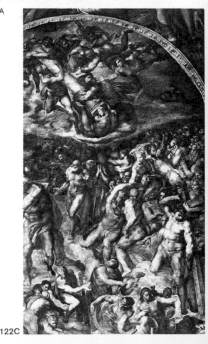

122C

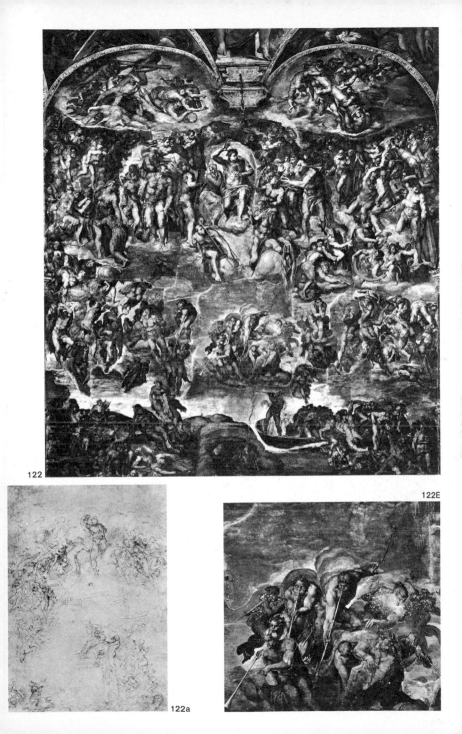

122

122a

122E

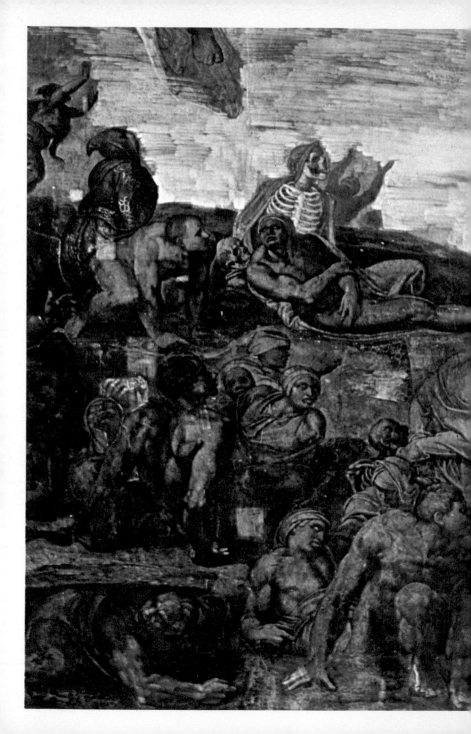

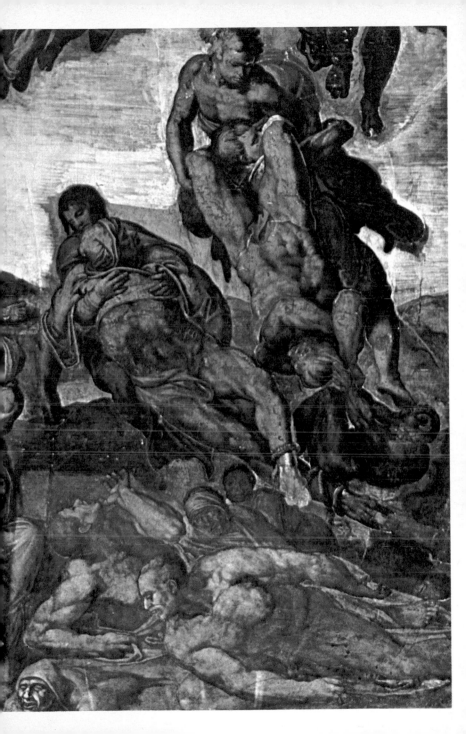

The Last Judgement
(No. 122G; detail) (pp. 86–7).
The dead rise up from the earth and begin to clothe themselves in flesh. Bottom left.

122D Centre left: the elect ascending to Heaven.

122E Centre: trumpet-blowing angels.

122F Centre right: the damned falling to Hell.

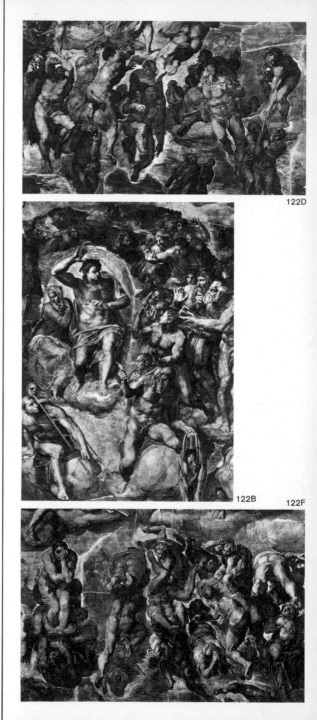

122D

122B

122F

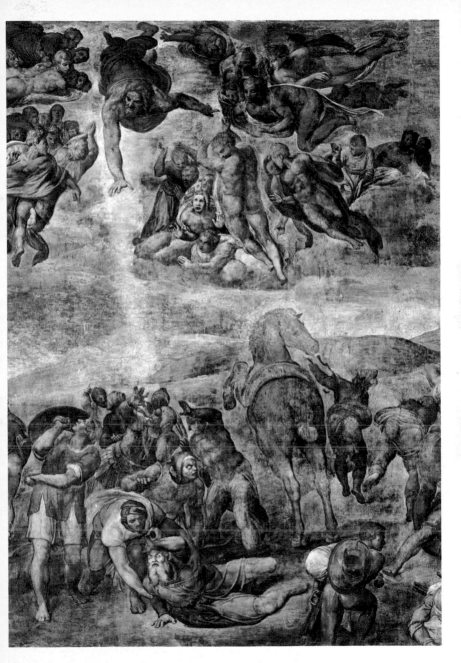

***The Conversion of Saul** (No. 125; detail)*. *On the right, just out of sight, is the city of Damascus. Saul's horse, seen directly from the back, charging into the background away from the spectator, was a dramatic innovation in painting.*

89

The Crucifixion of St Peter (*No. 126; detail*) (*pp. 92–3*). St Peter, nailed head downwards on his cross, makes a superhuman attempt to turn round. Underneath him a soldier digs a hole to put the cross in.

122G

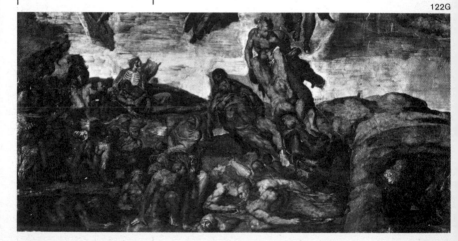

122H

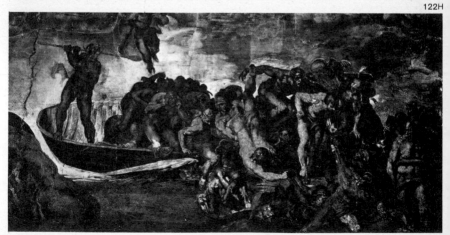

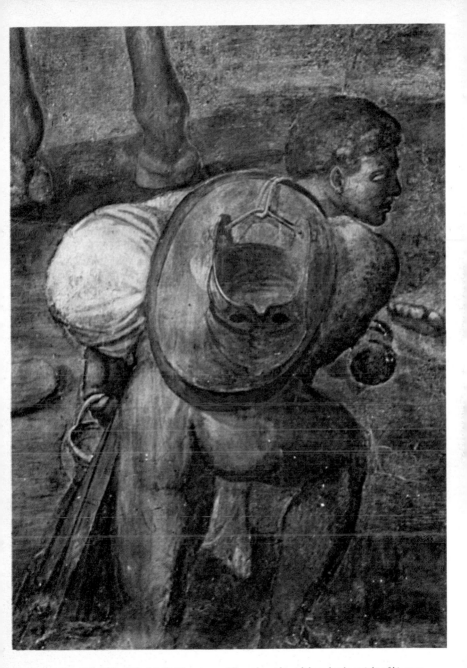

The Conversion of Saul (*No. 125; detail*). *The young soldier, almost bowed down by the weight of his arms and equipment, reacts the minimum to the supernatural event.*

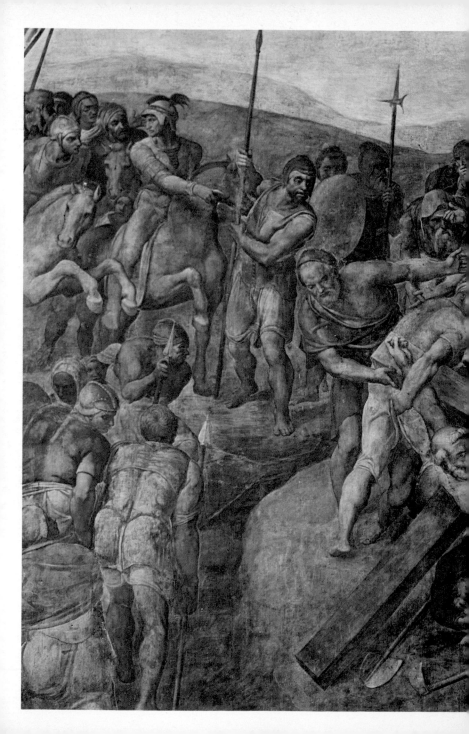

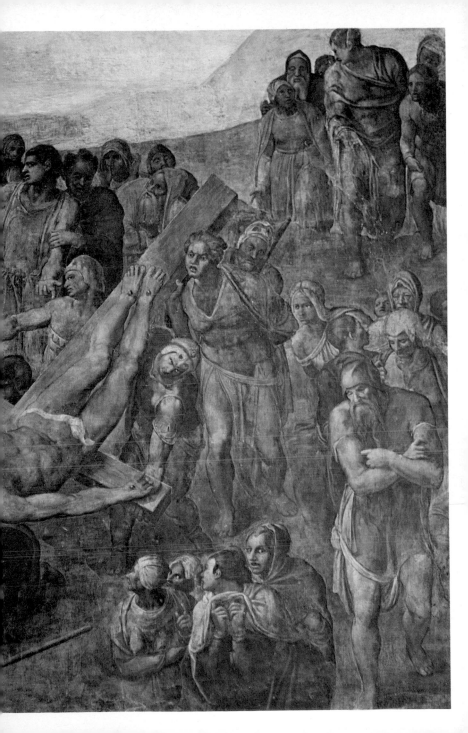

123 Leda
c. 1530
Lost work, known through
copies and descriptions, an
engraving by Cornelis Bos
(Photo 123a) and a copy-
cartoon in the Royal
Academy, London (Photo
123b).

124 In addition to the few
easel pictures which
Michelangelo painted himself
a number of paintings were
made by other artists after
cartoons and drawings by
him (see Introduction). Photo
124a (Cambridge, Fitzwilliam
Museum) is thought to be for
a cartoon of CHRIST TAKING
LEAVE OF HIS MOTHER, which
was recorded in an inventory
taken after Michelangelo's
death.

THE PAULINE CHAPEL FRESCOES

125 The Conversion of Saul
Fresco/625 × 661/1542–5

126 The Crucifixion of St Peter
Fresco/625 × 662/1545–50
A preparatory cartoon for the
warriors on the left of the
fresco is shown in Photo 126a
(Naples, Gallerie Nazionali di
Capodimonte).

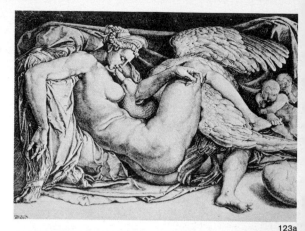

123a

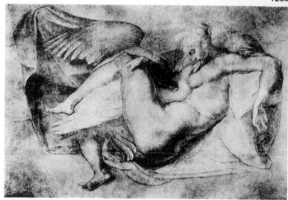

123b

126a

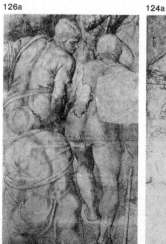

124a

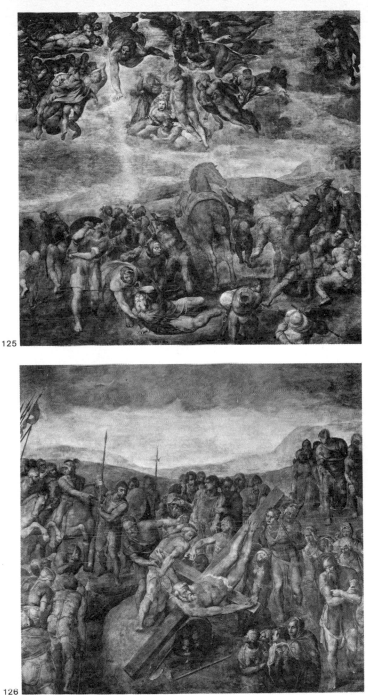

125

126

Bibliography

The vast literature on Michelangelo is recorded in the following works in particular:

E. STEINMANN and R. WITTKOWER: *Michelangelo Bibliographie 1510–1926.* Leipzig 1927

E. STEINMANN: *Michelangelo im Spiegel seiner Zeit.* Leipzig 1930

P. CHERUBELLI: in *Michelangelo Buonarroti nel IV centenario del Giudizio Universale.* Florence 1942

P. BAROCCHI: *La vita di Michelangelo di G. Vasari.* Naples 1965

In addition, a selection of the main early sources and some of the most important modern studies on Michelangelo, dealing with his painting in particular, are listed below:

A. CONDIVI: *Vita di Michelangelo Buonarroti.* Rome 1553

G. VASARI: *Le Vite.* Florence 1550 and 1568

G. MILANESI: *Le lettere di Michelangelo Buonarroti.* Florence 1875

K. FREY: *Die Dichtungen des Michelangelo Buonarroti.* Berlin 1897

H. THODE: *Michelangelo und das Ende der Renaissance.* Berlin 1908–13

A. FORATTI: 'Gli Ignudi della volta Sistina', in *L'Arte* 1918

V. MARIANI: *Gli affreschi di Michelangelo nella Cappella Paolina.* Rome 1932

A. BERTINI: *Michelangelo fino alla Sistina.* Turin 1942

C. DE TOLNAY: *Michelangelo.* 5 vols. Princeton 1943–60

L. GOLDSCHEIDER: *Michelangelo.* Florence-London 1953

D. REDIG DE CAMPOS: *Il Giudizio Universale.* Milan 1964

E. PANOFSKY: *Studies in Iconology.* 1964 edn, New York and Evenston

P. BAROCCHI: *Il carteggio di Michelangelo.* Florence 1965

R. SALVINI, E. CAMESASCA and C. L. RAGGHIANTI: *La Cappella Sistina in Vaticano.* Milan 1965

E. CAMESASCA: *Michelangelo pittore.* Milan 1966

M. BUONARROTI: *Le Rime,* ed. G. Testori and E. Barelli. Milan 1975

R. DE MAIO: *Michelangelo e la Controriforma.* Bari 1978

J. WILDE: *Six Lectures on Michelangelo.* Oxford 1978

Photocredits

All black and white photographs are from the Rizzoli Photoarchive as are the colour photographs on pp. 34–5, 43, 51, 55, 59, 70–71, 73, 75, 77, 78–9, 81, 82–3, 86–7, 89, 91, 92–3.

The colour photographs on pp. 11, 13, 15, 18–19, 21, 23, 25, 26–7, 30–31, 37, 39, 40–41, 45, 47, 49, 53, 57, 61, 63, 66–7, 69 are from Scala.

First published in the United States of America 1980 by Rizzoli International Publications, Inc.
712 Fifth Avenue, New York, New York 10019
Copyright © Rizzoli Editore 1979
This translation copyright © Granada Publishing 1980
Introduction copyright © Cecil Gould 1980
ISBN 0-8478-0310-4
LC 80-50233
Printed in Italy